COLORING DC

BATMAN: MAD LOVE
FEATURING HARLEY QUINN

PAUL **DINI** Writer

BRUCE **TIMM** Artist

TIM **HARKINS**
RICHARD **STARKINGS/COMICRAFT**
Letterers

BATMAN CREATED BY BOB KANE
WITH BILL FINGER

HARLEY QUINN CREATED BY PAUL DINI
AND BRUCE TIMM

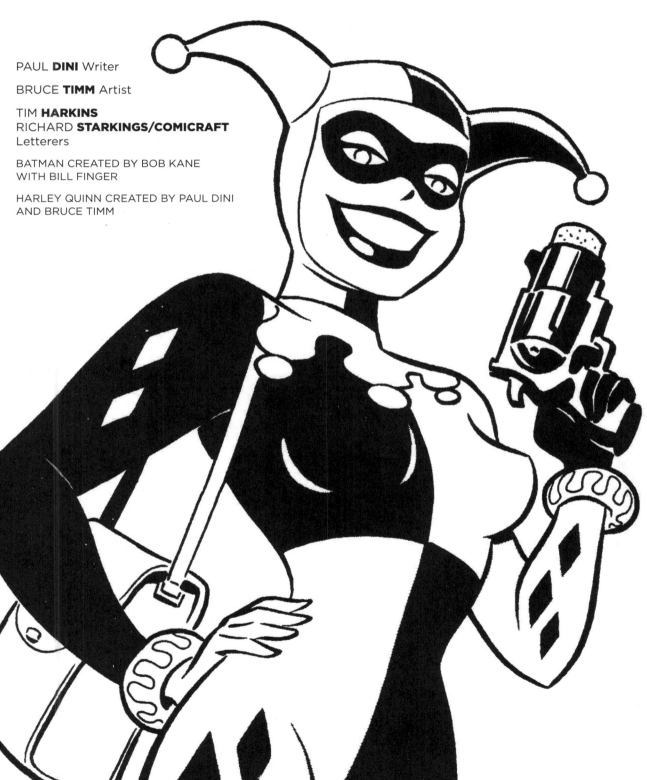

Scott Peterson Editor – Original Series
Darren Vincenzo Associate Editor – Original Series
Jeb Woodard Group Editor – Collected Editions
Steve Cook Design Director – Books
 & Publication Design

Bob Harras Senior VP – Editor-in-Chief, DC Comics

Diane Nelson President
Dan DiDio
and Jim Lee Co-Publishers
Geoff Johns Chief Creative Officer
Amit Desai Senior VP – Marketing & Global Franchise Management
Nairi Gardiner Senior VP – Finance
Sam Ades VP – Digital Marketing
Bobbie Chase VP – Talent Development
Mark Chiarello Senior VP – Art, Design & Collected Editions
John Cunningham VP – Content Strategy
Anne DePies VP – Strategy Planning & Reporting
Don Falletti VP – Manufacturing Operations
Lawrence Ganem VP – Editorial Administration & Talent Relations
Alison Gill Senior VP – Manufacturing & Operations
Hank Kanalz Senior VP – Editorial Strategy & Administration
Jay Kogan VP – Legal Affairs
Derek Maddalena Senior VP – Sales & Business Development
Jack Mahan VP – Business Affairs
Dan Miron VP – Sales Planning & Trade Development
Nick Napolitano VP – Manufacturing Administration
Carol Roeder VP – Marketing
Eddie Scannell VP – Mass Account & Digital Sales
Courtney Simmons Senior VP – Publicity & Communications
Jim (Ski) Sokolowski VP – Comic Book Specialty & Newsstand Sales
Sandy Yi Senior VP – Global Franchise Management

COLORING DC – BATMAN: MAD LOVE FEATURING HARLEY QUINN

DC Comics, 2900 West Alameda Ave., Burbank, CA 91505
Printed by RR Donnelley, Willard, OH, USA. 8/16/16.
Third Printing. ISBN: 978-1-4012-6614-1

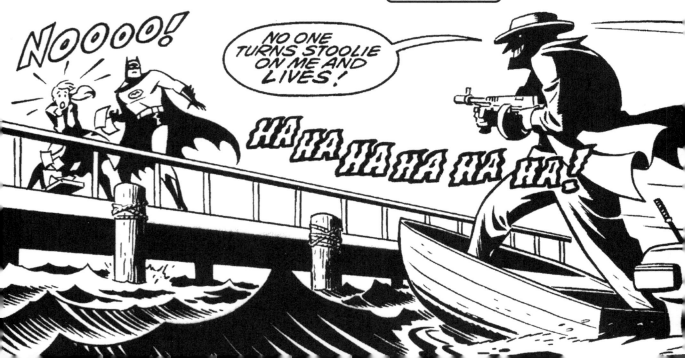

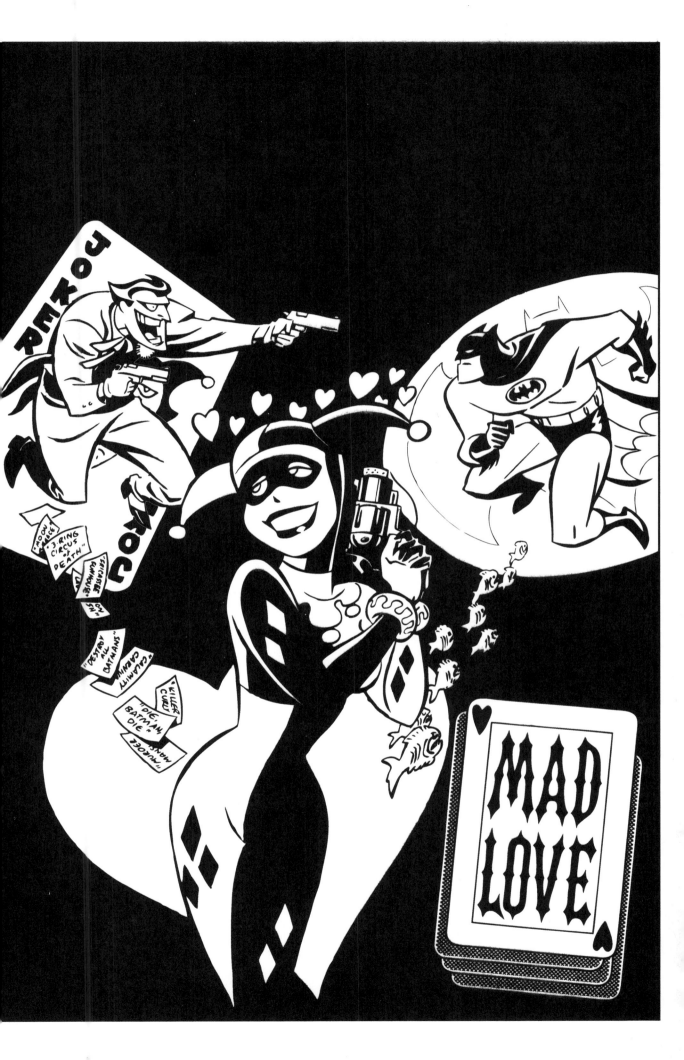

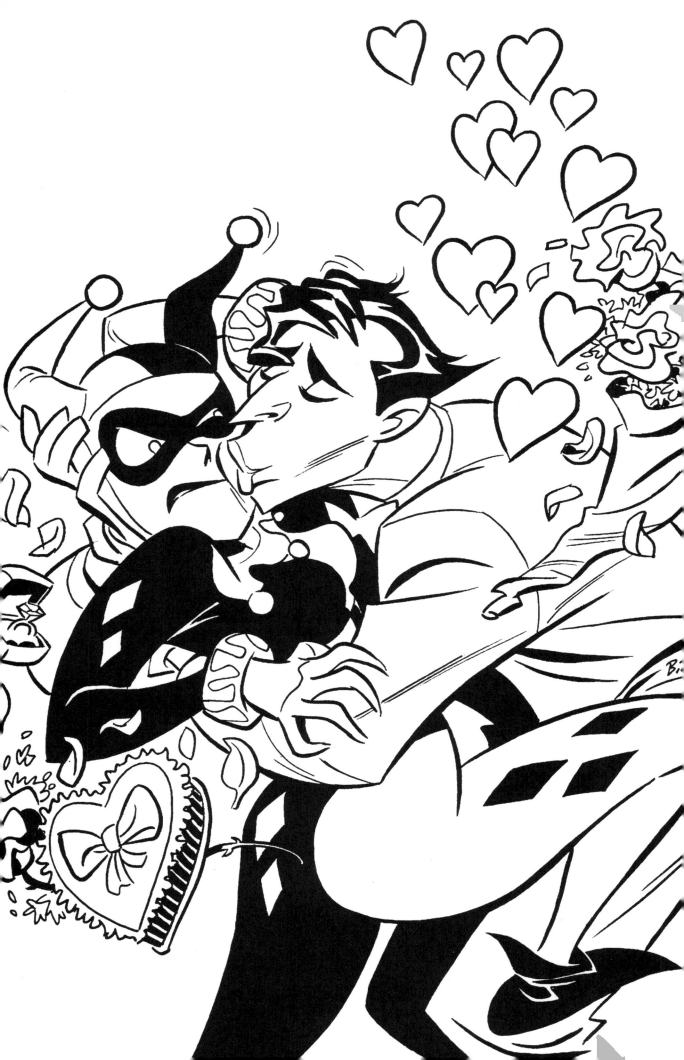

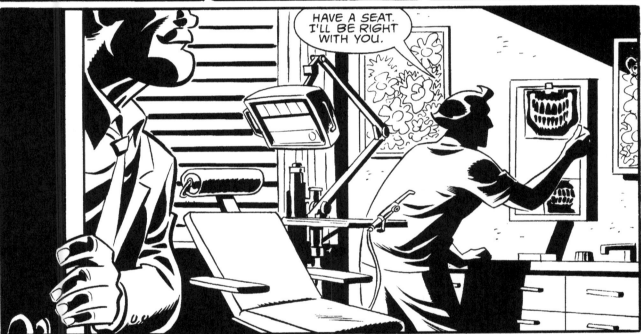

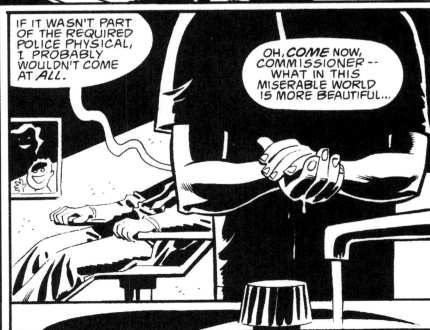

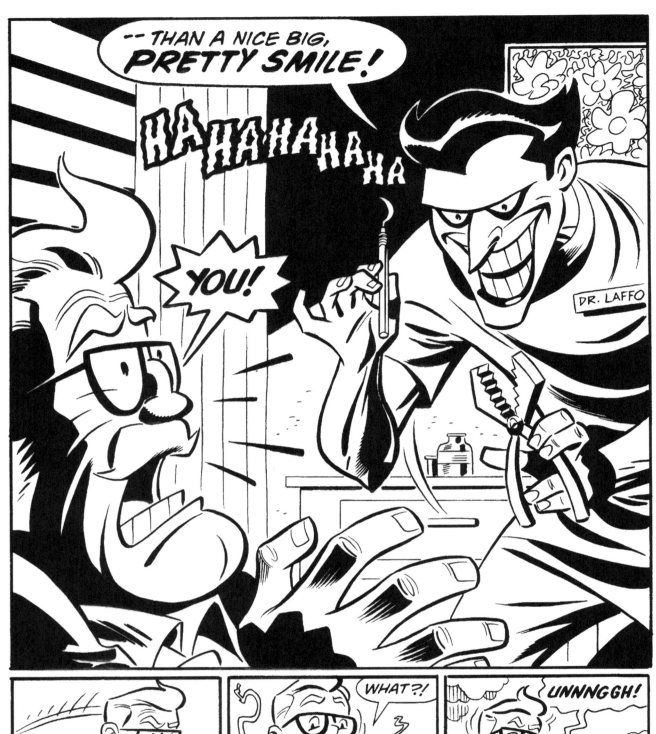

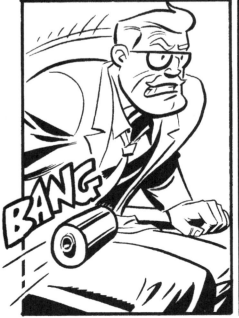

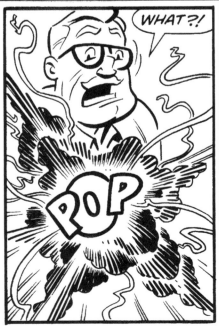

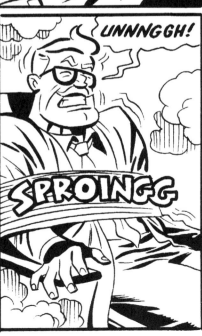

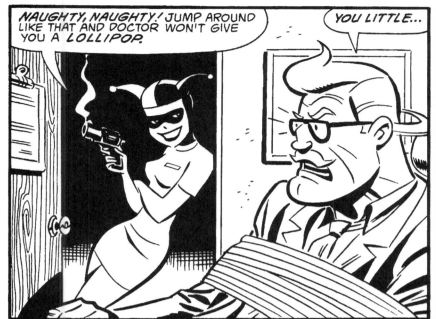

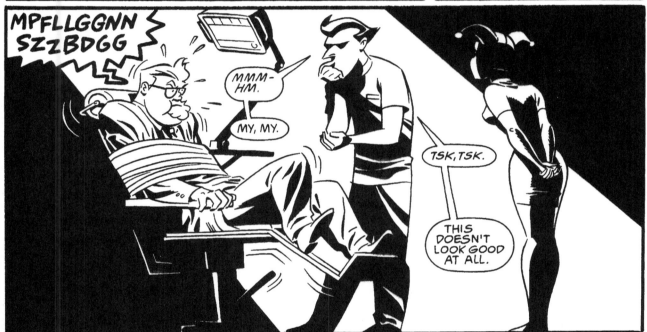

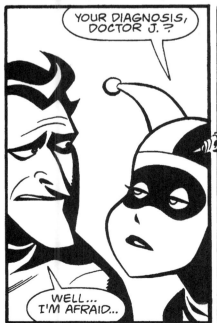

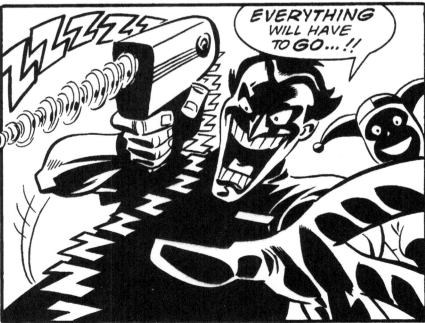

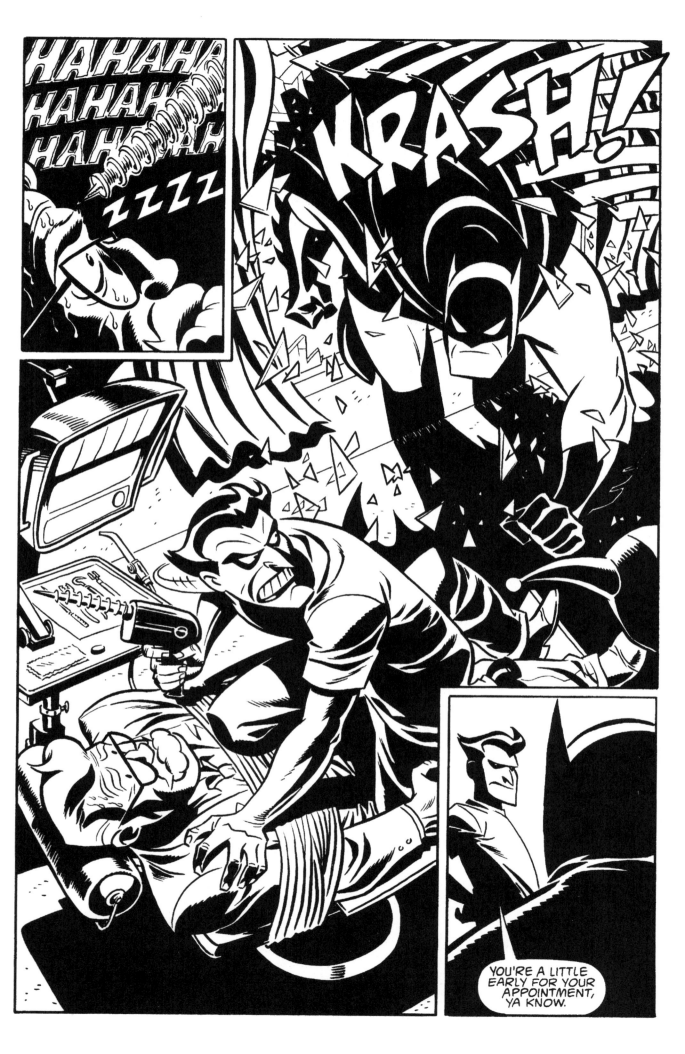

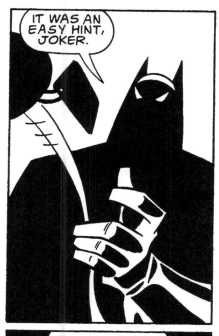

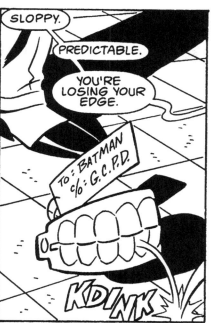

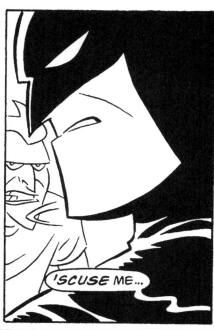

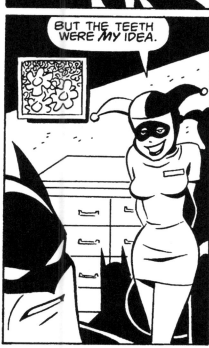

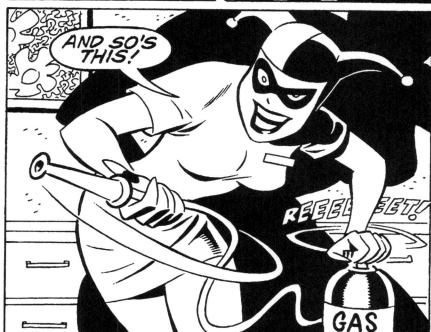

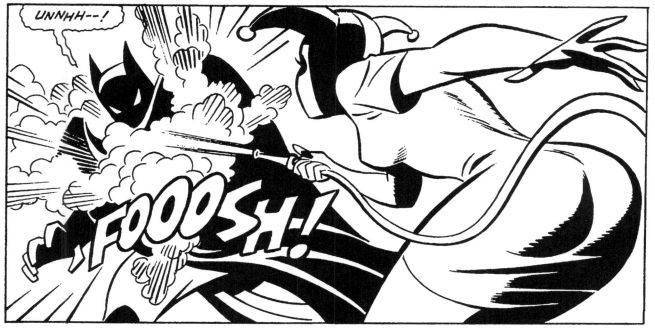

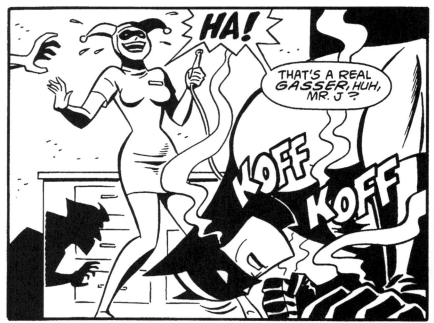

HA!

THAT'S A REAL GASSER, HUH, MR. J?

KOFF KOFF

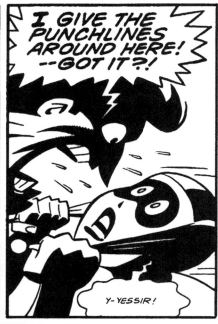

I GIVE THE PUNCHLINES AROUND HERE! --GOT IT?!

Y-YESSIR!

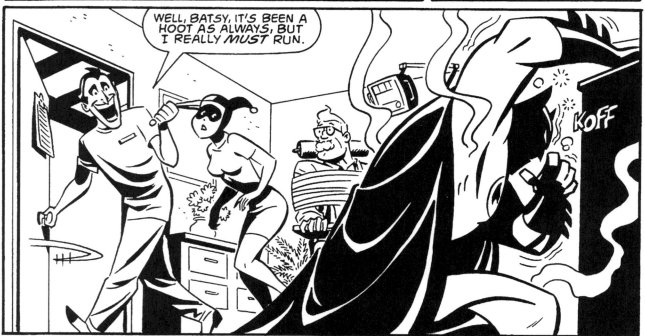

WELL, BATSY, IT'S BEEN A HOOT AS ALWAYS, BUT I REALLY MUST RUN.

KOFF

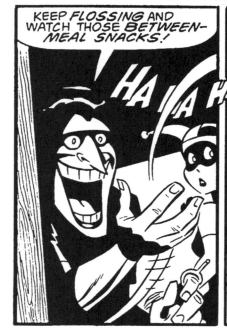

KEEP FLOSSING AND WATCH THOSE BETWEEN-MEAL SNACKS!

HA HA HA

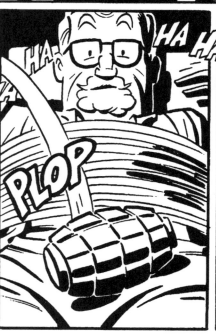

HA HA HA HA HA

PLOP

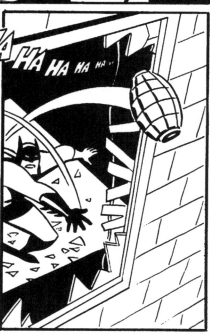

HA HA HA HA

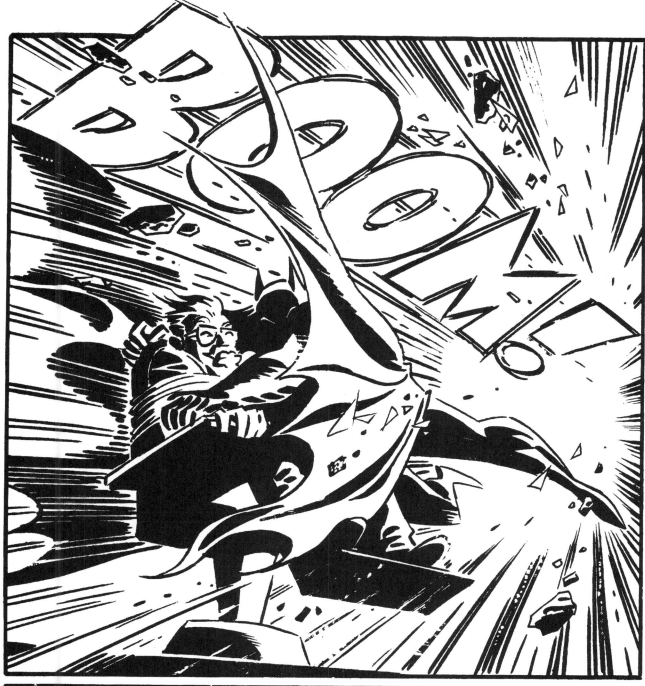

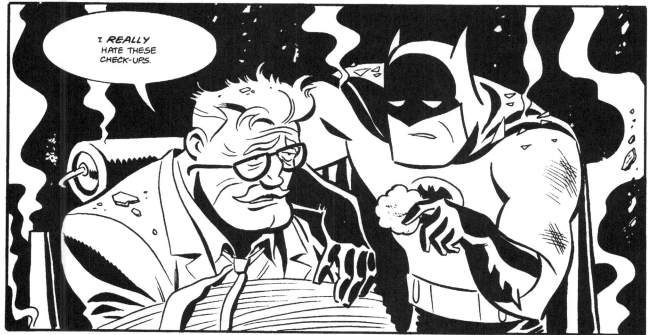

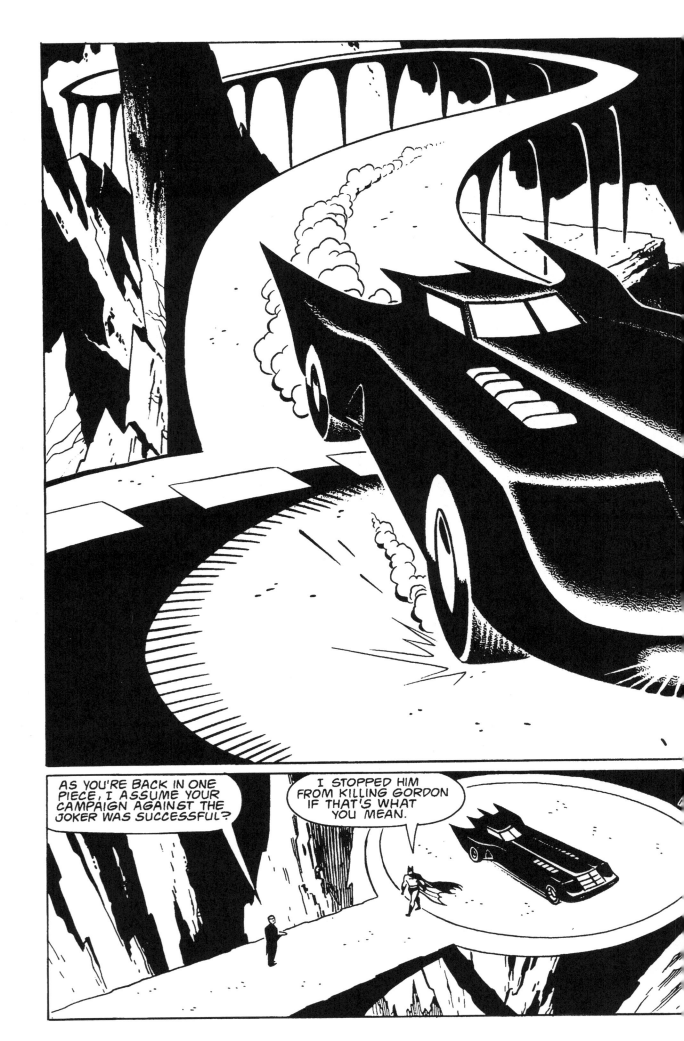

"MAD LOVE"

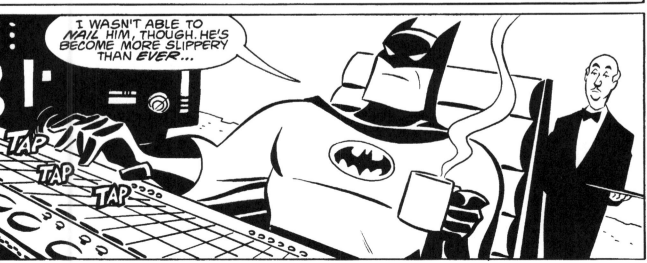

I WASN'T ABLE TO *NAIL* HIM, THOUGH. HE'S BECOME MORE SLIPPERY THAN *EVER...*

TAP

TAP

TAP

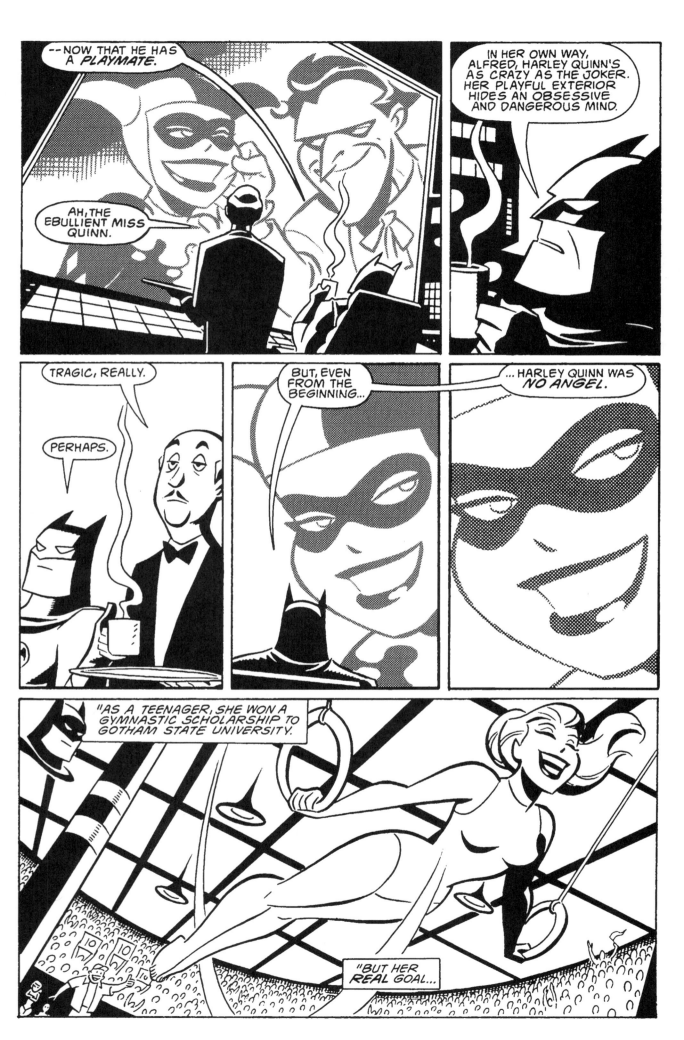

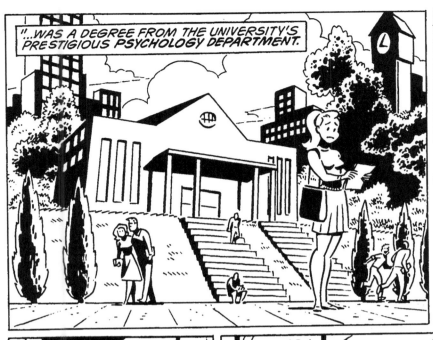

"...WAS A DEGREE FROM THE UNIVERSITY'S PRESTIGIOUS *PSYCHOLOGY DEPARTMENT.*

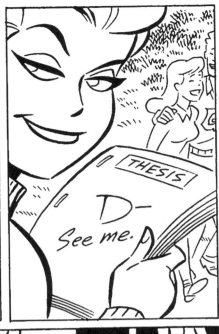

THESIS

D—
See me.

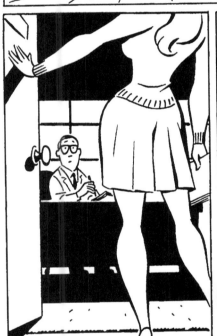

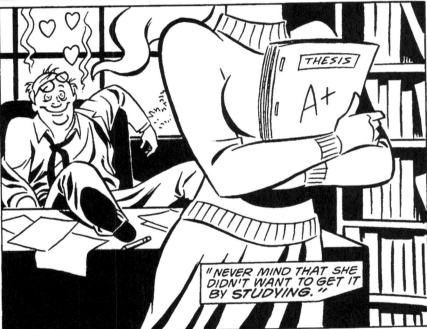

THESIS

A+

"NEVER MIND THAT SHE DIDN'T WANT TO GET IT BY *STUDYING.*"

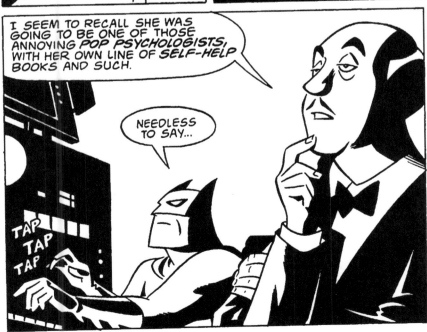

I SEEM TO RECALL SHE WAS GOING TO BE ONE OF THOSE ANNOYING *POP PSYCHOLOGISTS,* WITH HER OWN LINE OF *SELF-HELP* BOOKS AND SUCH.

NEEDLESS TO SAY...

TAP TAP TAP

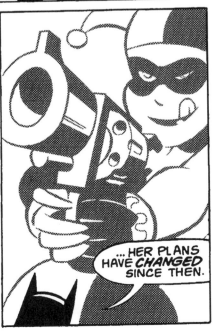

...HER PLANS HAVE *CHANGED* SINCE THEN.

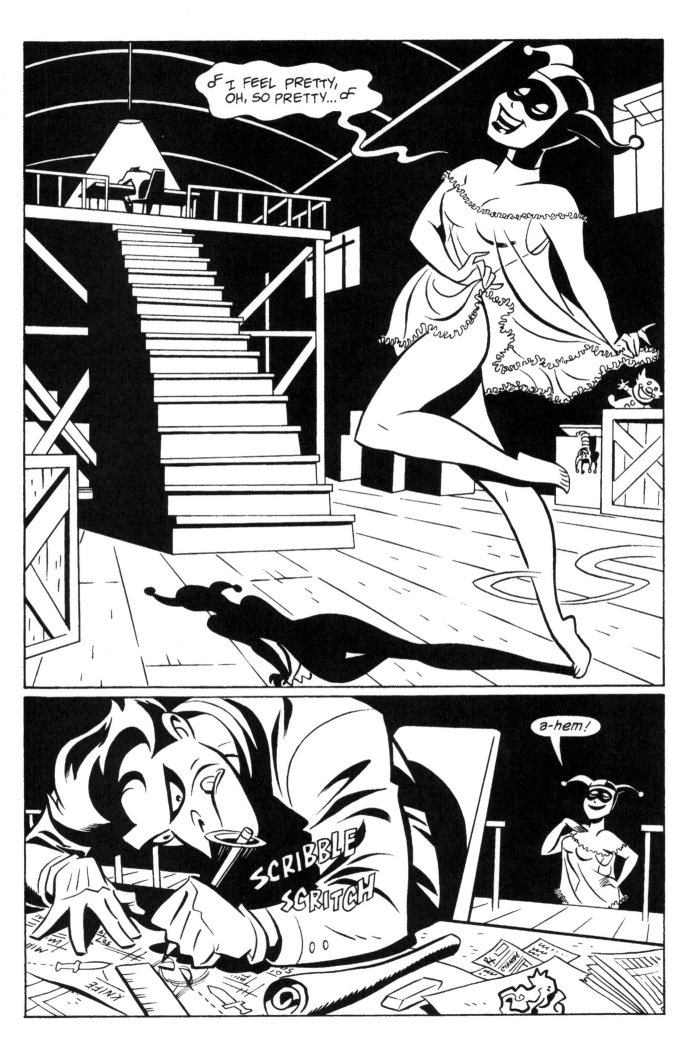

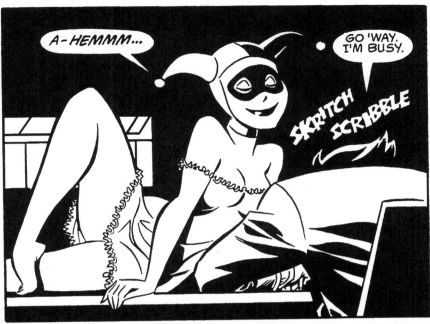

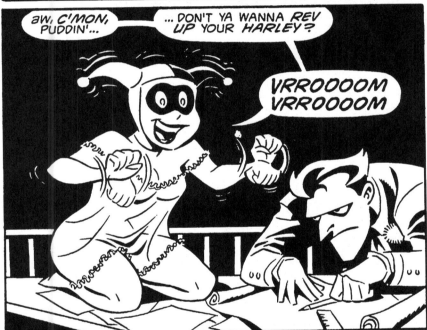

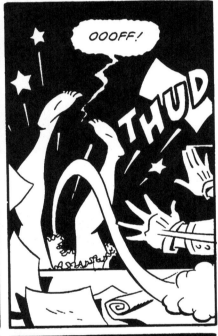

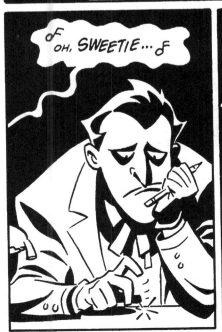

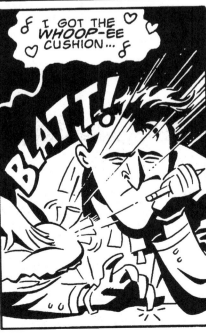

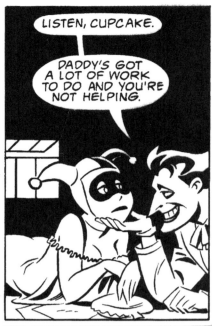

LISTEN, CUPCAKE.

DADDY'S GOT A LOT OF WORK TO DO AND YOU'RE NOT HELPING.

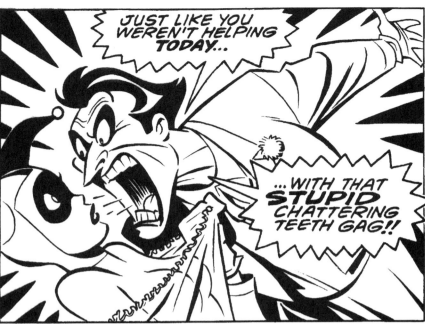

JUST LIKE YOU WEREN'T HELPING *TODAY*...

...WITH THAT *STUPID* CHATTERING TEETH GAG!!

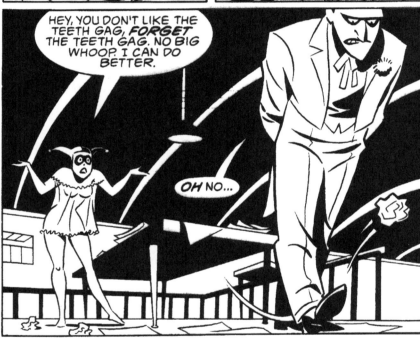

HEY, YOU DON'T LIKE THE TEETH GAG, *FORGET* THE TEETH GAG. NO BIG WHOOP. I CAN DO BETTER.

OH NO...

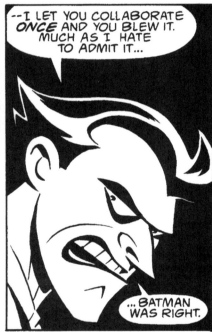

--I LET YOU COLLABORATE *ONCE* AND YOU BLEW IT. MUCH AS I HATE TO ADMIT IT...

...BATMAN WAS RIGHT.

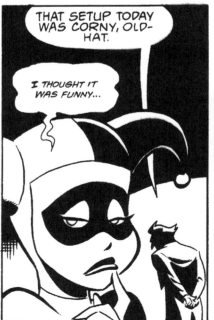

THAT SETUP TODAY WAS CORNY, OLD-HAT.

I THOUGHT IT WAS FUNNY...

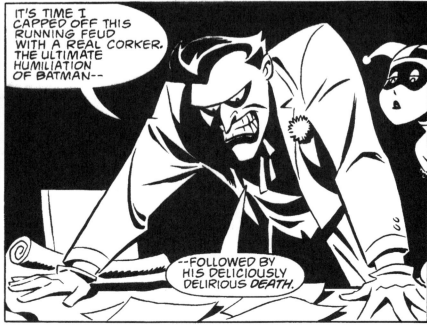

IT'S TIME I CAPPED OFF THIS RUNNING FEUD WITH A REAL CORKER. THE ULTIMATE HUMILIATION OF BATMAN--

--FOLLOWED BY HIS DELICIOUSLY DELIRIOUS *DEATH*.

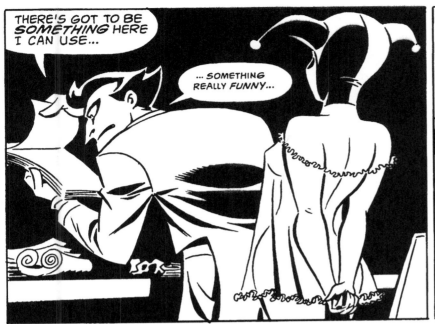
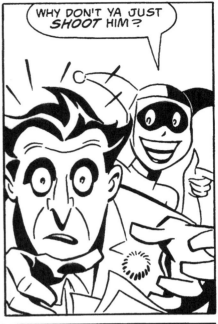

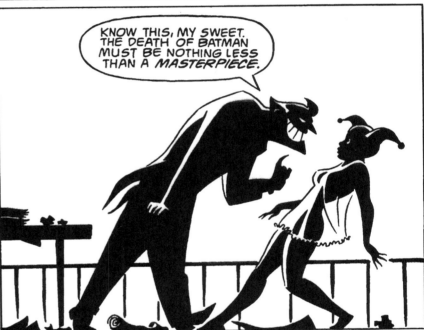
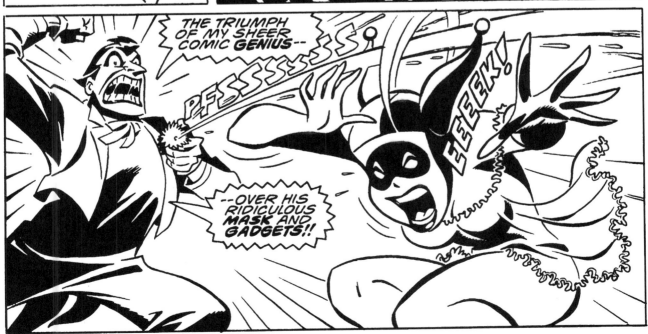

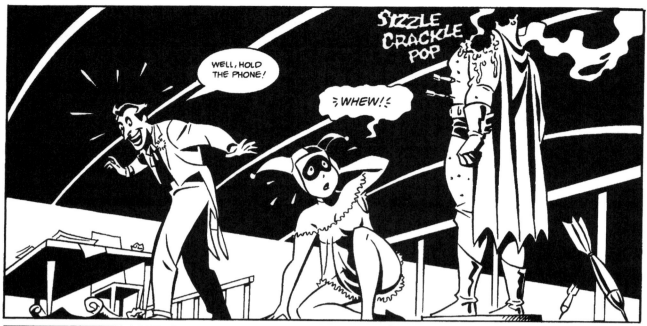

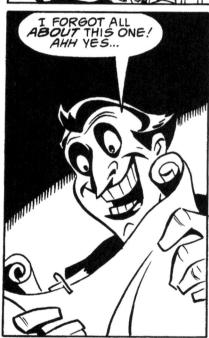

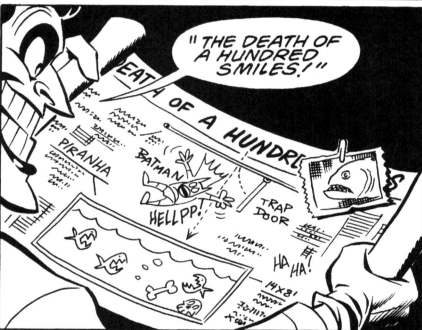

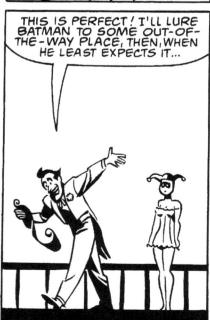

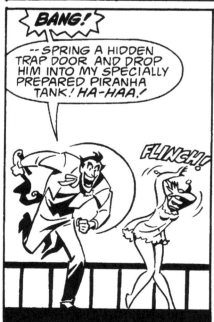

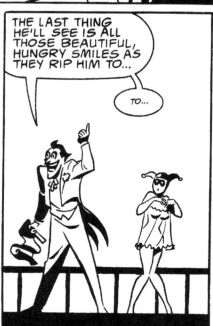

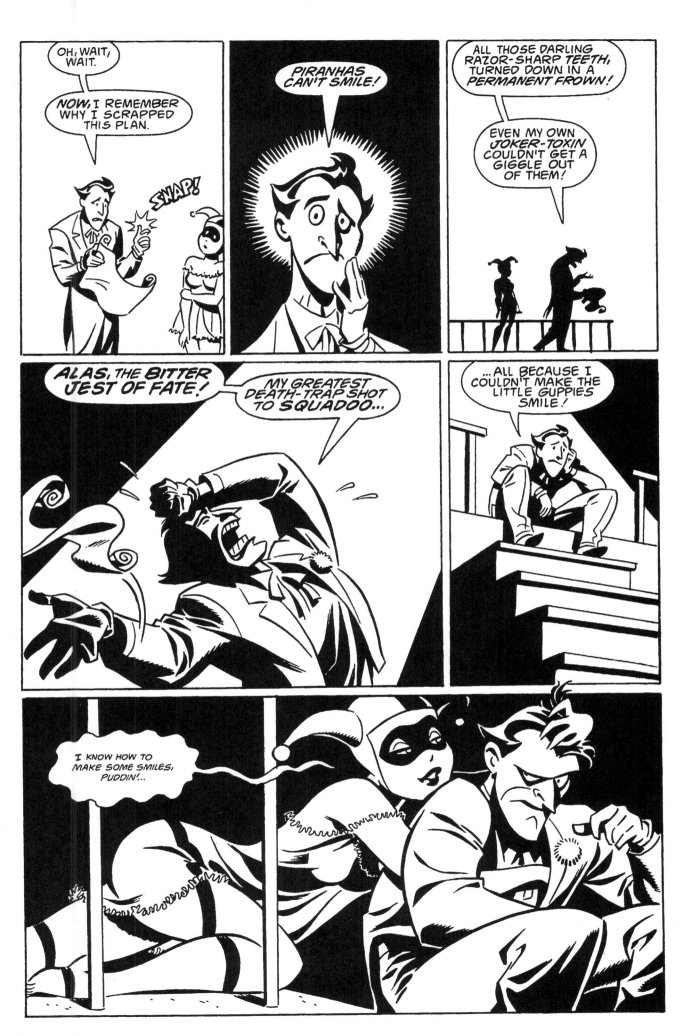

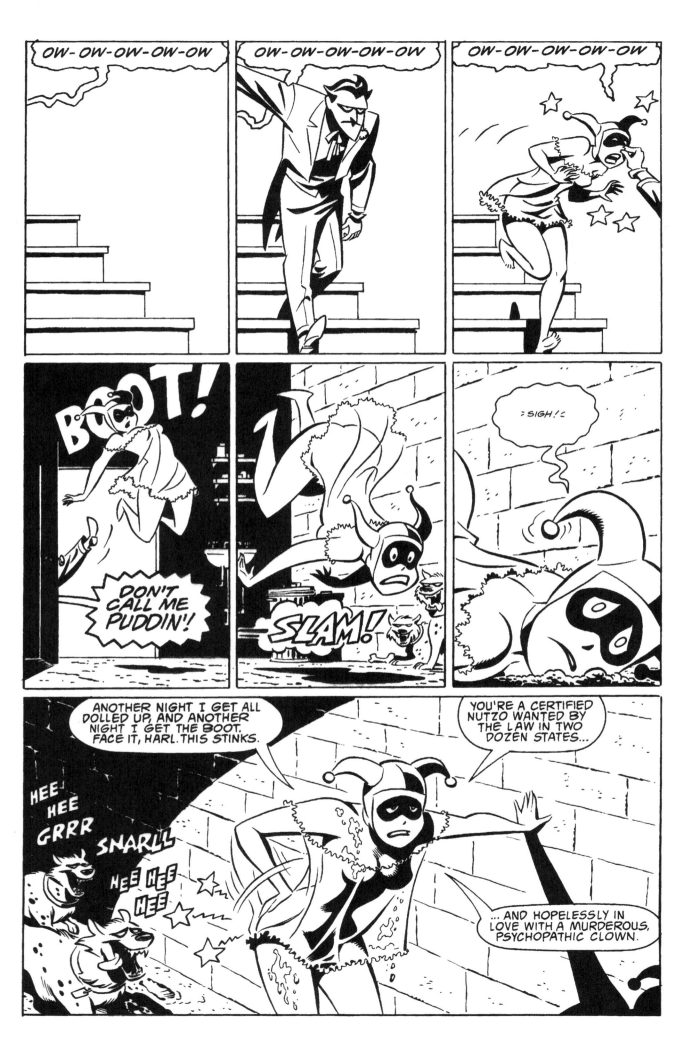

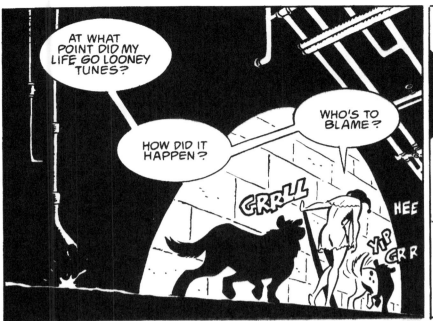

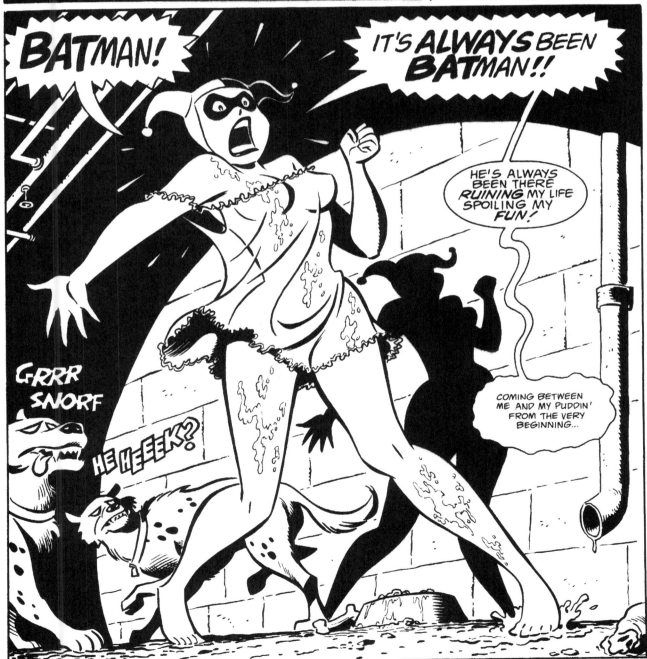

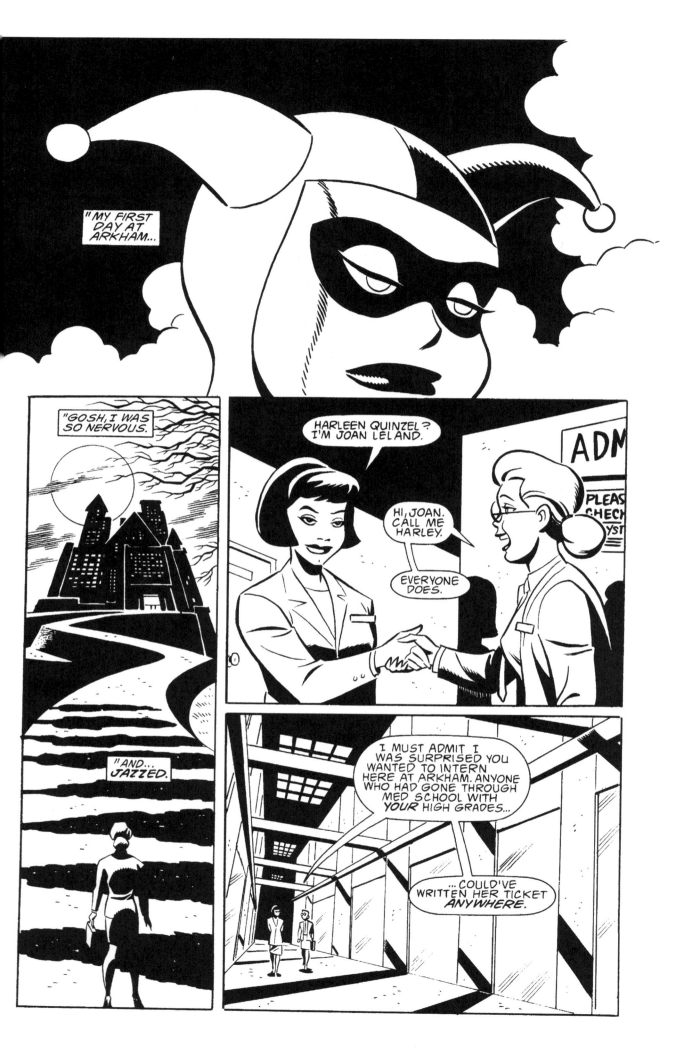

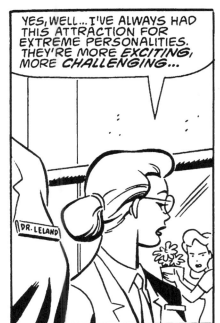

YES, WELL... I'VE ALWAYS HAD THIS ATTRACTION FOR EXTREME PERSONALITIES. THEY'RE MORE *EXCITING,* MORE *CHALLENGING...*

DR. LELAND

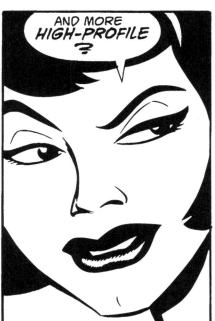

AND MORE *HIGH-PROFILE*?

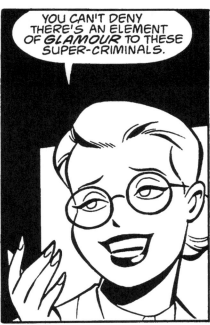

YOU CAN'T DENY THERE'S AN ELEMENT OF *GLAMOUR* TO THESE SUPER-CRIMINALS.

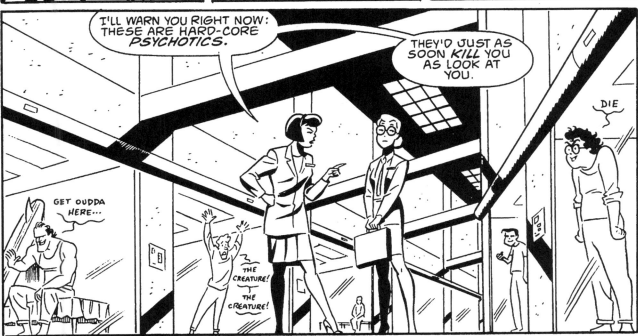

I'LL WARN YOU RIGHT NOW: THESE ARE HARD-CORE *PSYCHOTICS.*

THEY'D JUST AS SOON *KILL* YOU AS LOOK AT YOU.

DIE

GET OUDDA HERE...

THE CREATURE!

THE CREATURE!

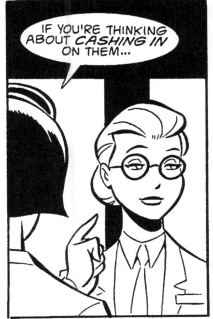

IF YOU'RE THINKING ABOUT *CASHING IN* ON THEM...

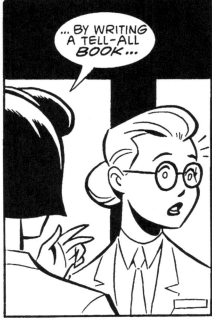

...BY WRITING A TELL-ALL *BOOK...*

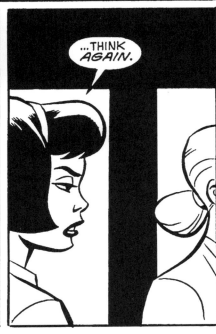

...THINK *AGAIN.*

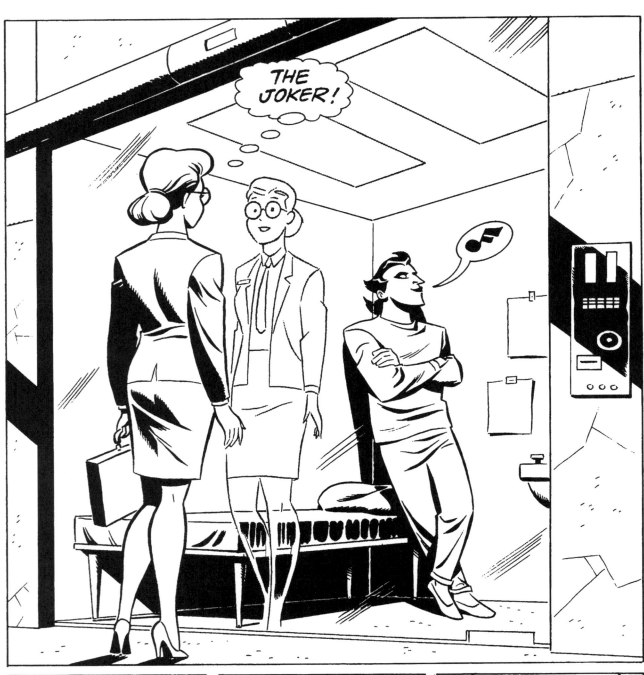

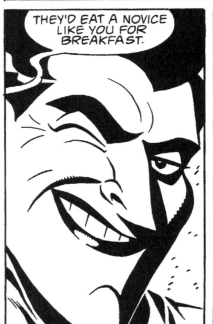

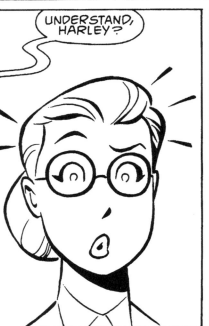

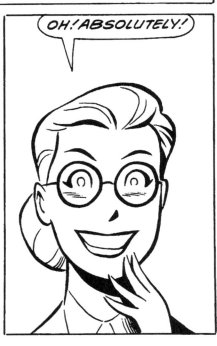

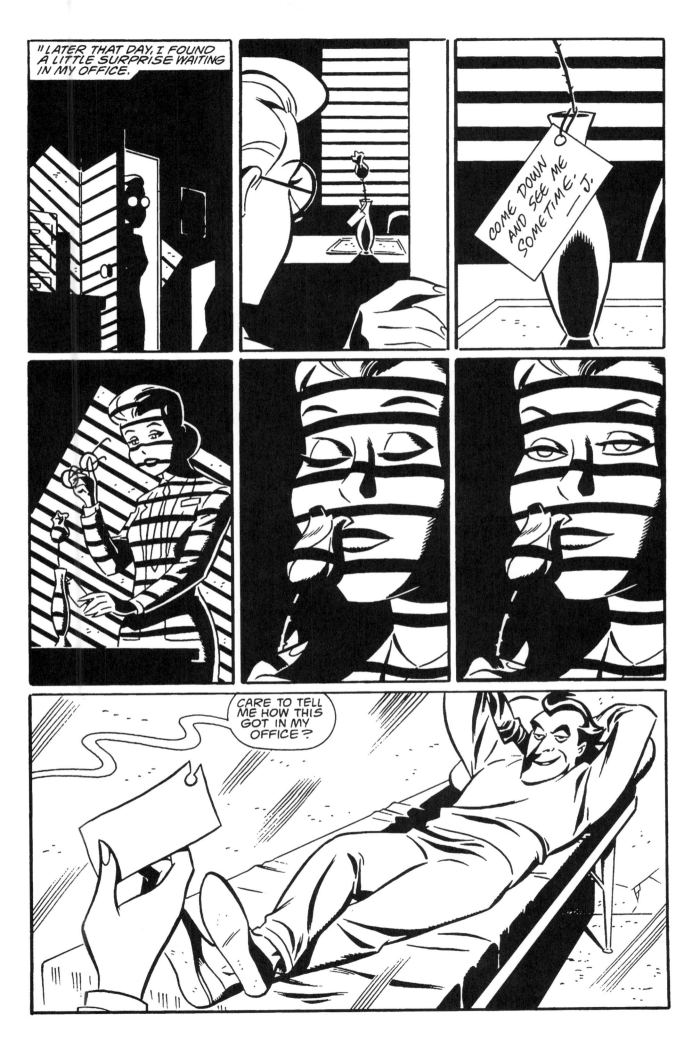

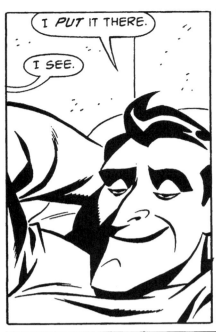

I *PUT* IT THERE.

I SEE.

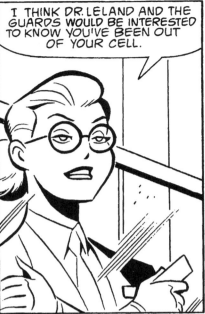

I THINK DR. LELAND AND THE GUARDS WOULD BE INTERESTED TO KNOW YOU'VE BEEN OUT OF YOUR CELL.

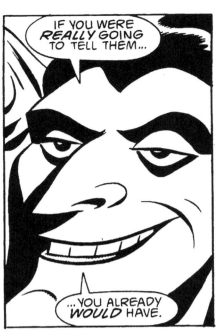

IF YOU WERE *REALLY* GOING TO TELL THEM...

...YOU ALREADY *WOULD* HAVE.

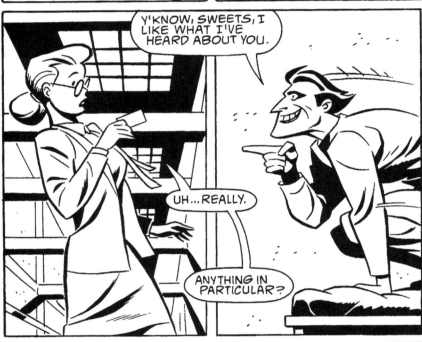

Y'KNOW, SWEETS, I LIKE WHAT I'VE HEARD ABOUT YOU.

UH...REALLY.

ANYTHING IN PARTICULAR?

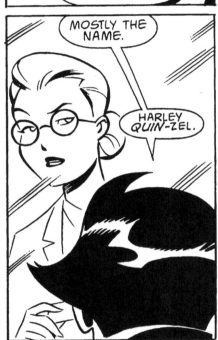

MOSTLY THE NAME.

HARLEY *QUIN*-ZEL.

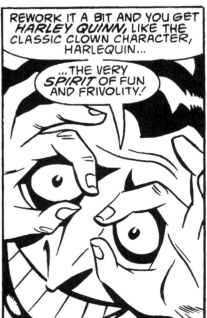

REWORK IT A BIT AND YOU GET *HARLEY QUINN*, LIKE THE CLASSIC CLOWN CHARACTER, HARLEQUIN...

...THE VERY *SPIRIT* OF FUN AND FRIVOLITY!

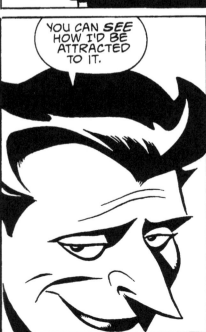

YOU CAN *SEE* HOW I'D BE ATTRACTED TO IT.

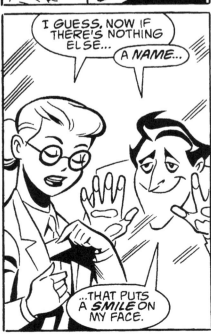

I GUESS, NOW IF THERE'S NOTHING ELSE...

A *NAME*...

...THAT PUTS A *SMILE* ON MY FACE.

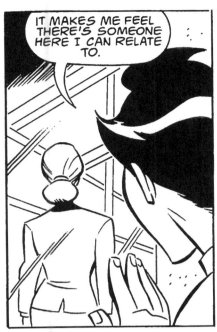

IT MAKES ME FEEL THERE'S SOMEONE HERE I CAN RELATE TO.

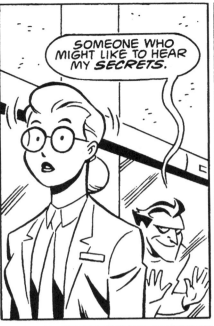

SOMEONE WHO MIGHT LIKE TO HEAR MY *SECRETS*.

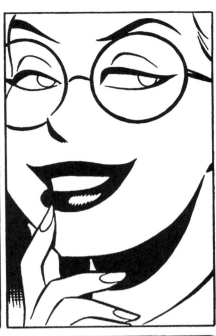

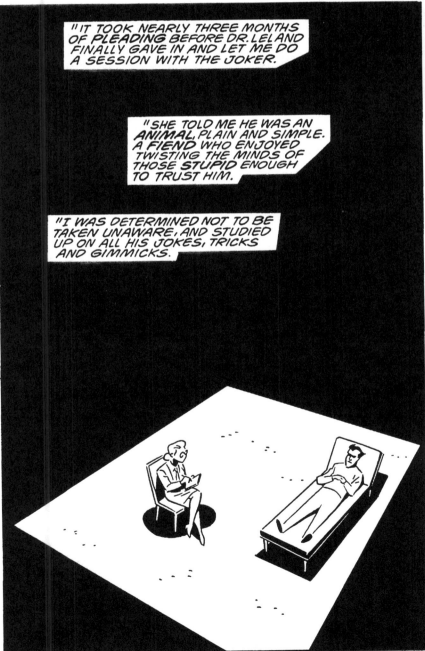

"IT TOOK NEARLY THREE MONTHS OF *PLEADING* BEFORE DR. LELAND FINALLY GAVE IN AND LET ME DO A SESSION WITH THE JOKER.

"SHE TOLD ME HE WAS AN *ANIMAL*, PLAIN AND SIMPLE. A *FIEND* WHO ENJOYED TWISTING THE MINDS OF THOSE *STUPID* ENOUGH TO TRUST HIM.

"I WAS DETERMINED NOT TO BE TAKEN UNAWARE, AND STUDIED UP ON ALL HIS JOKES, TRICKS AND GIMMICKS.

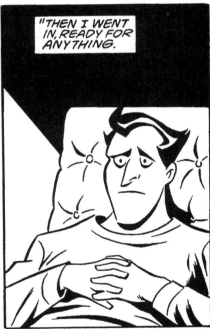

"THEN I WENT IN, READY FOR ANYTHING.

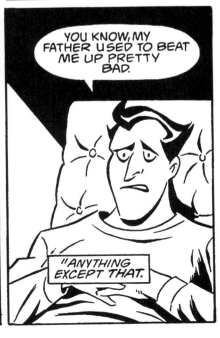

YOU KNOW, MY FATHER USED TO BEAT ME UP PRETTY BAD.

"ANYTHING EXCEPT THAT.

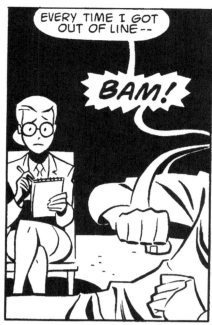

EVERY TIME I GOT OUT OF LINE--

BAM!

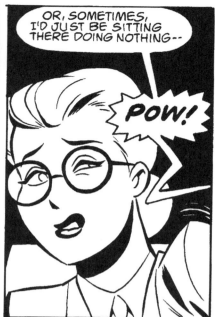

OR, SOMETIMES, I'D JUST BE SITTING THERE DOING NOTHING--

POW!

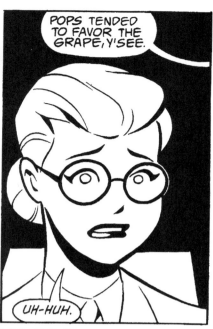

POPS TENDED TO FAVOR THE GRAPE, Y'SEE.

UH-HUH.

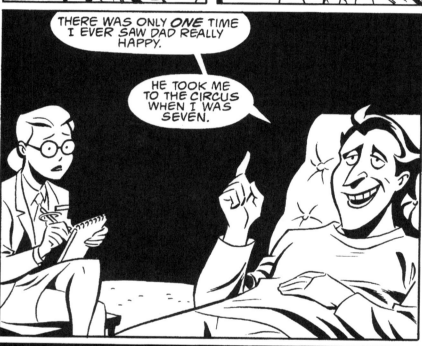

THERE WAS ONLY ONE TIME I EVER SAW DAD REALLY HAPPY.

HE TOOK ME TO THE CIRCUS WHEN I WAS SEVEN.

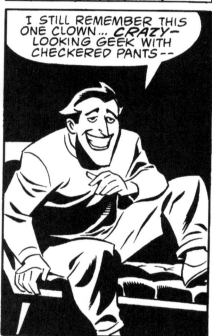

I STILL REMEMBER THIS ONE CLOWN... CRAZY-LOOKING GEEK WITH CHECKERED PANTS--

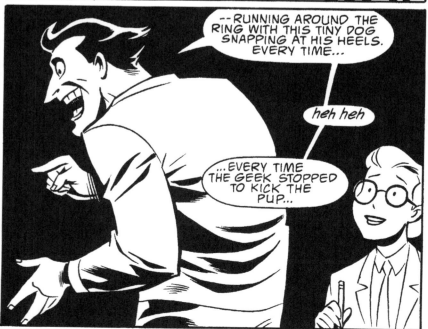

--RUNNING AROUND THE RING WITH THIS TINY DOG SNAPPING AT HIS HEELS. EVERY TIME...

...EVERY TIME THE GEEK STOPPED TO KICK THE PUP...

heh heh

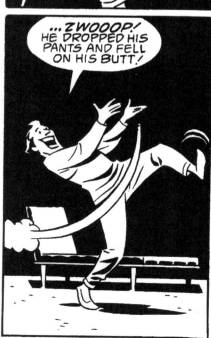

...ZWOOOP! HE DROPPED HIS PANTS AND FELL ON HIS BUTT!

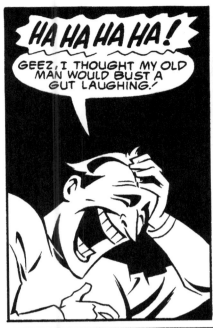

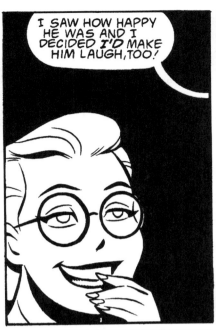

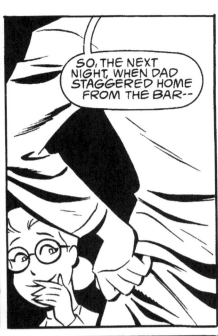

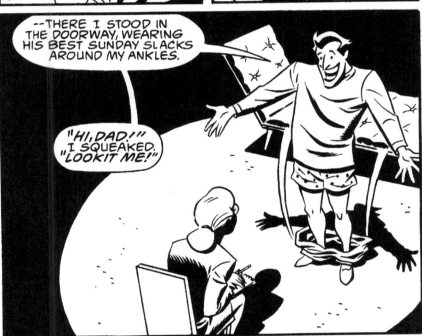

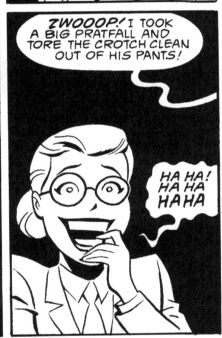

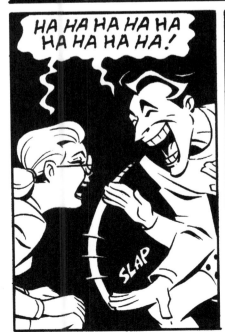

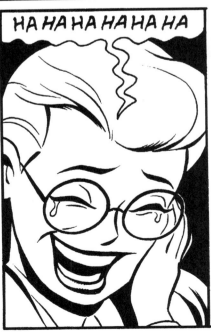

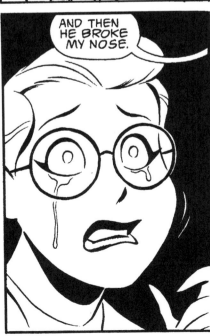

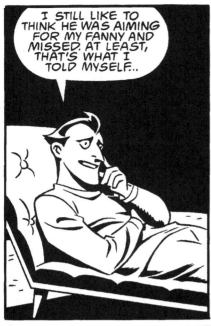

I STILL LIKE TO THINK HE WAS AIMING FOR MY FANNY AND MISSED. AT LEAST, THAT'S WHAT I TOLD MYSELF..

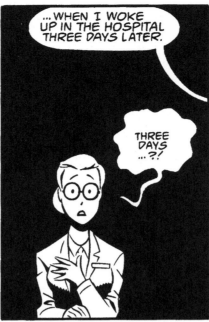

...WHEN I WOKE UP IN THE HOSPITAL THREE DAYS LATER.

THREE DAYS ...?!

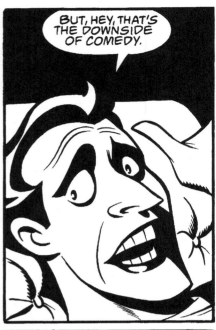

BUT, HEY, THAT'S THE DOWNSIDE OF COMEDY.

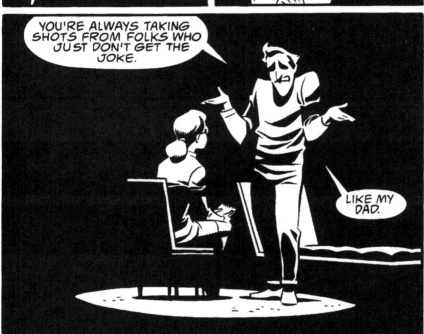

YOU'RE ALWAYS TAKING SHOTS FROM FOLKS WHO JUST DON'T GET THE JOKE.

LIKE MY DAD.

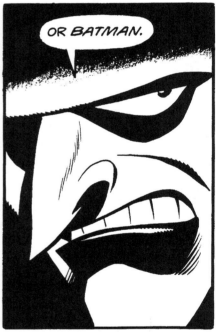

OR BATMAN.

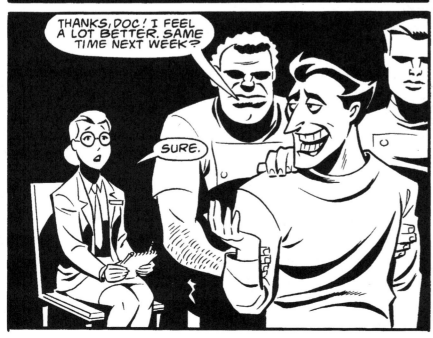

THANKS, DOC! I FEEL A LOT BETTER. SAME TIME NEXT WEEK?

SURE.

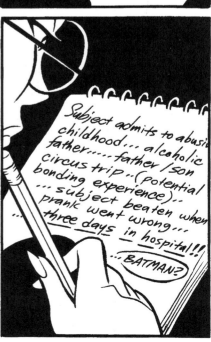

Subject admits to abusive childhood.... alcoholic father..... father/son circus trip..(potential bonding experience)... subject beaten when prank went wrong... three days in hospital!!

...BATMAN?

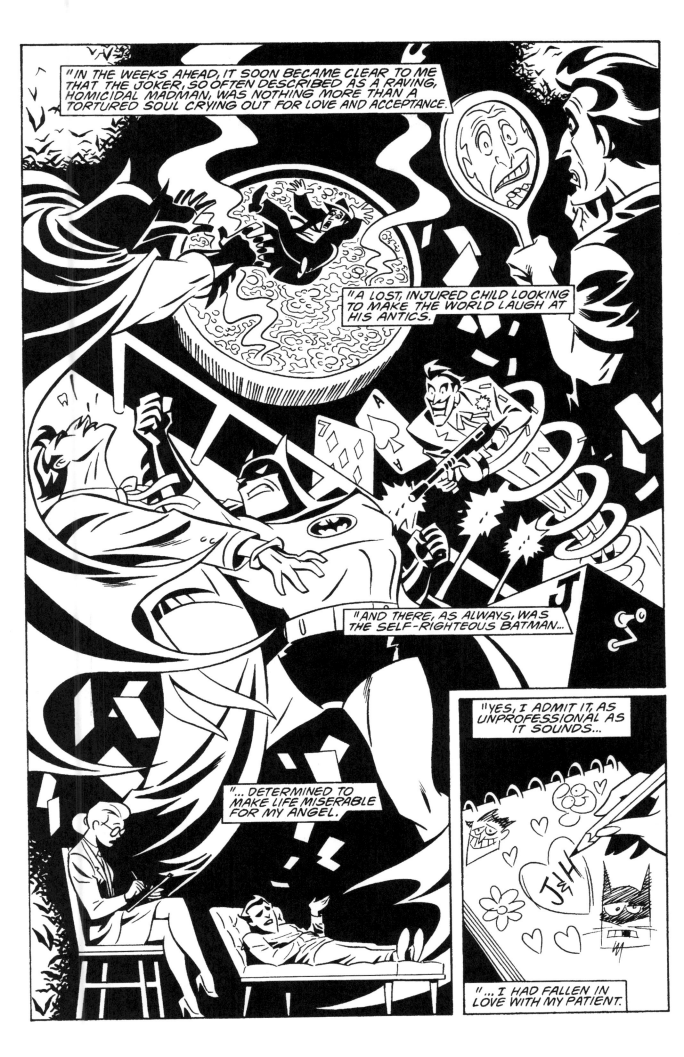

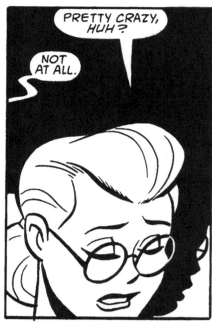

PRETTY CRAZY, HUH?

NOT AT ALL.

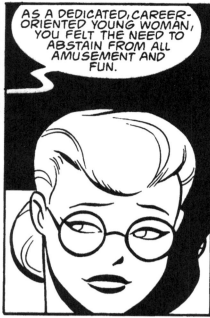

AS A DEDICATED, CAREER-ORIENTED YOUNG WOMAN, YOU FELT THE NEED TO ABSTAIN FROM ALL AMUSEMENT AND FUN.

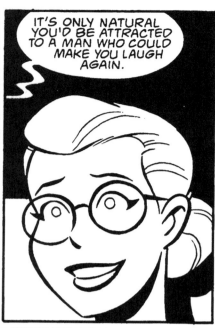

IT'S ONLY NATURAL YOU'D BE ATTRACTED TO A MAN WHO COULD MAKE YOU LAUGH AGAIN.

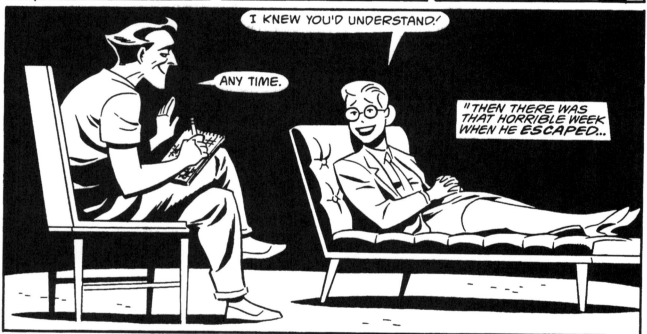

I KNEW YOU'D UNDERSTAND!

ANY TIME.

"THEN THERE WAS THAT HORRIBLE WEEK WHEN HE *ESCAPED*...

"...THE POOR THING WAS OUT ON THE RUN, ALONE AND FRIGHTENED. I WAS SO WORRIED!"

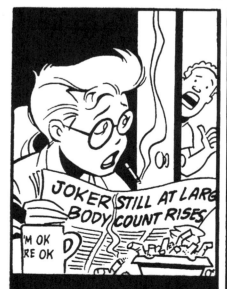

JOKER STILL AT LARGE BODY COUNT RISES

'M OK RE OK

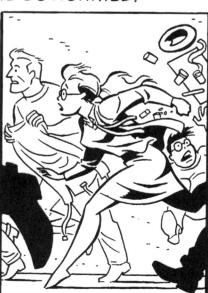

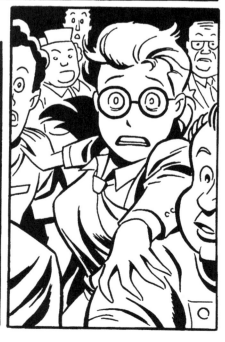

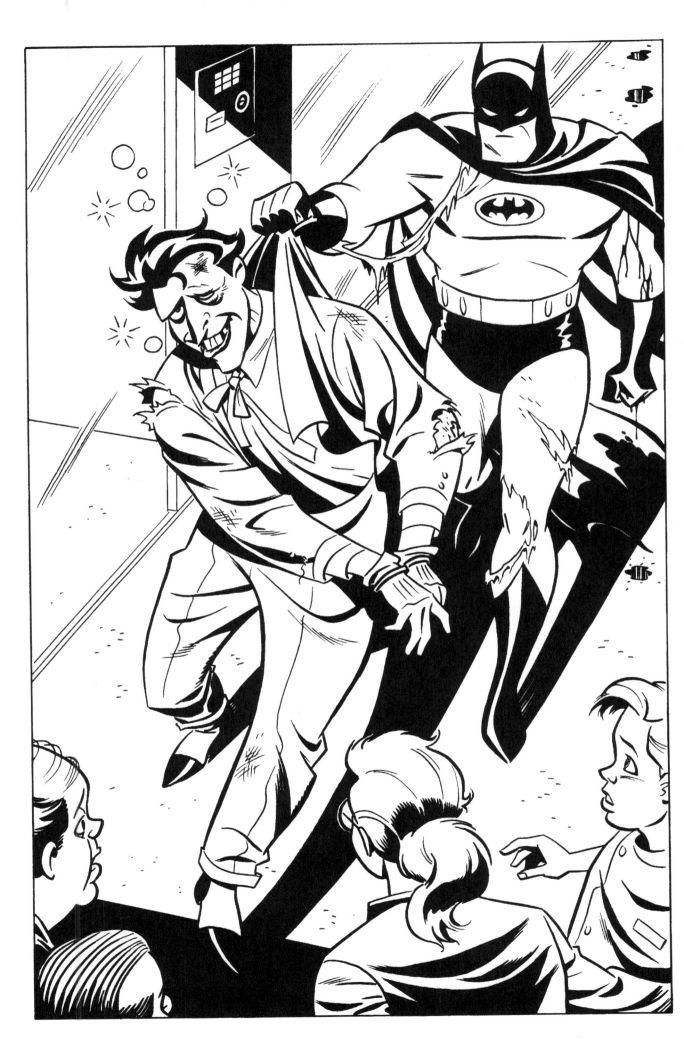

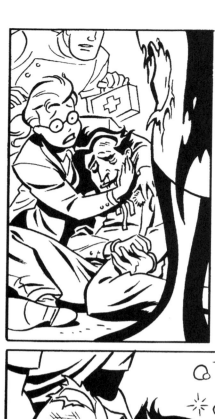
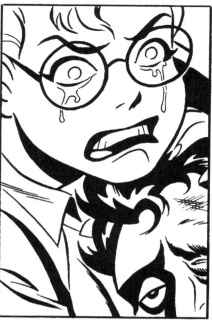
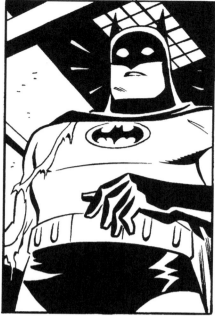
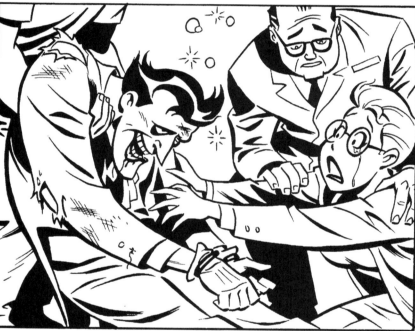
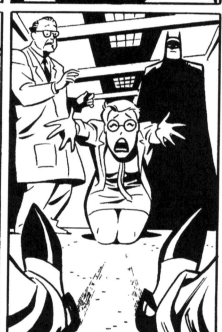
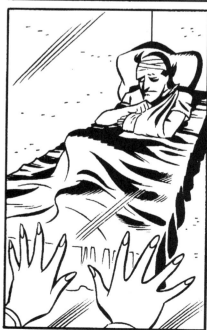
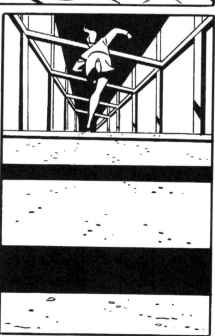
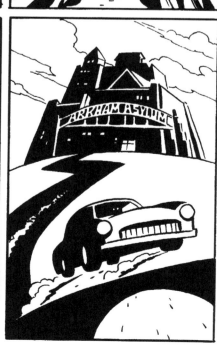

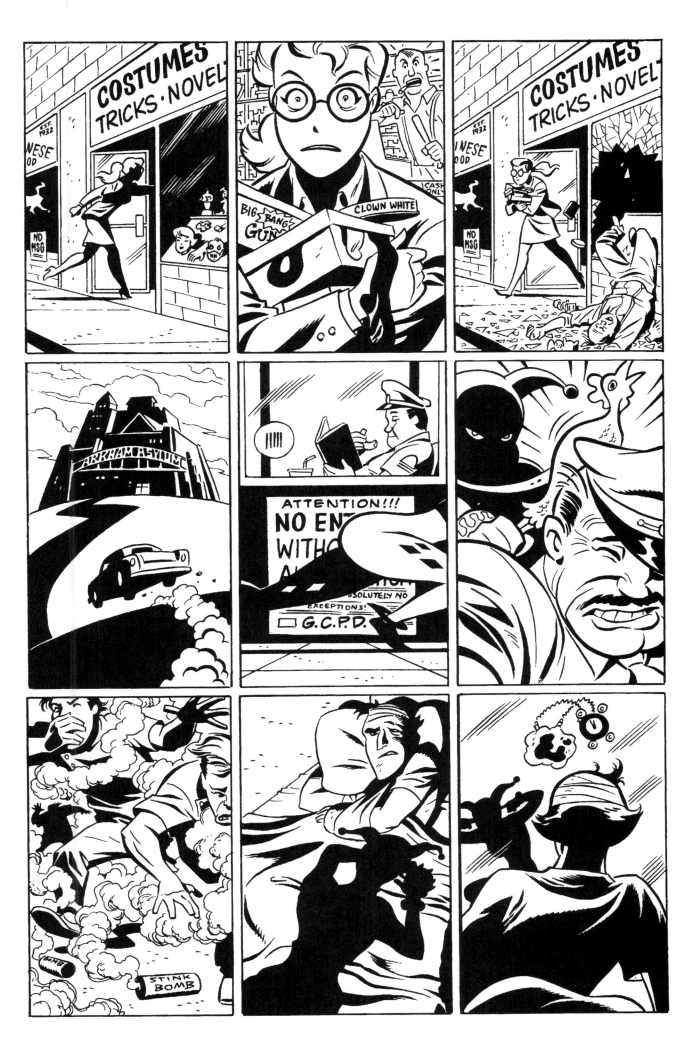

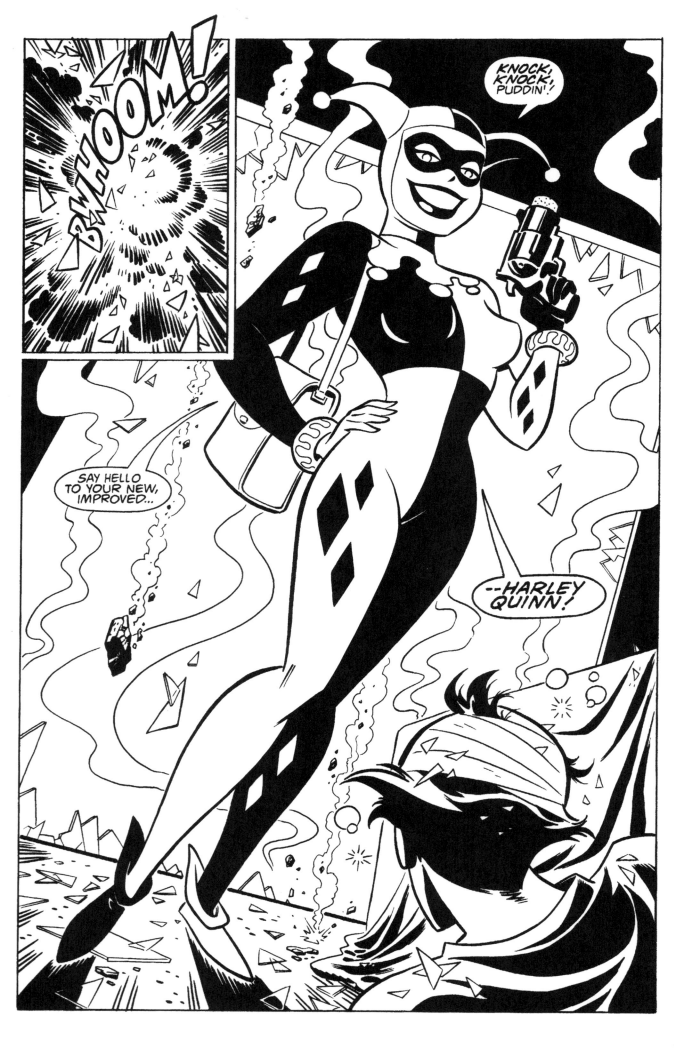

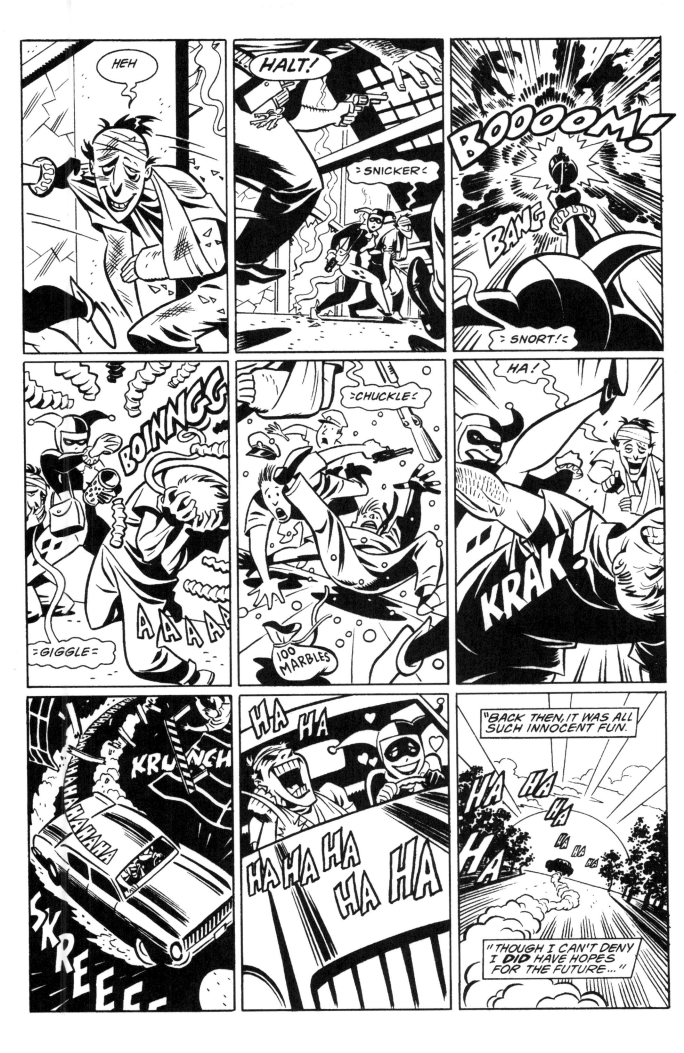

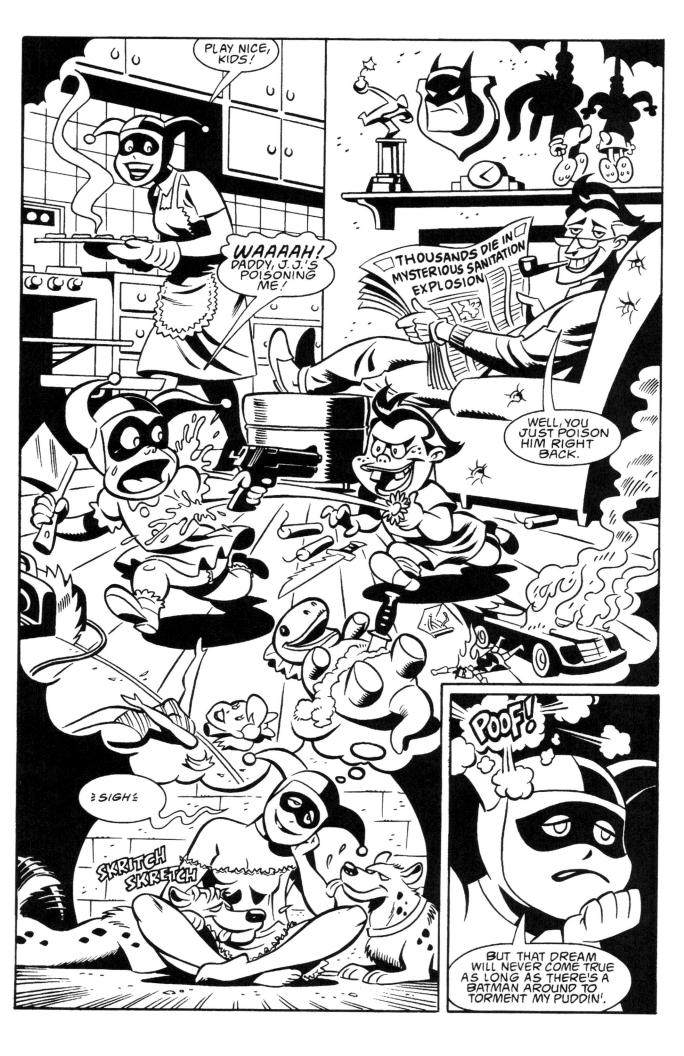

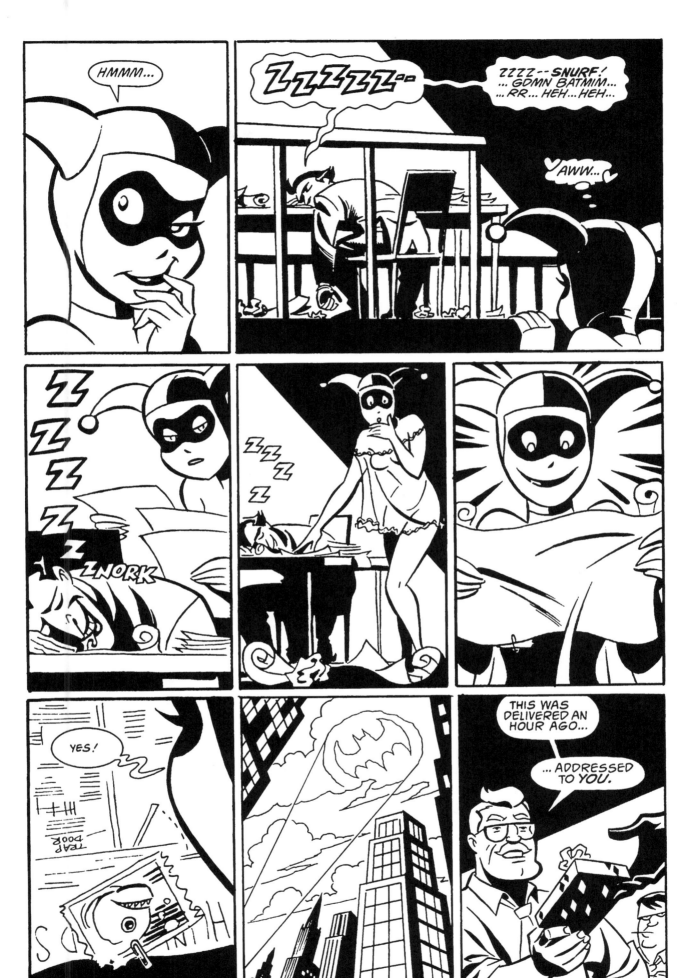

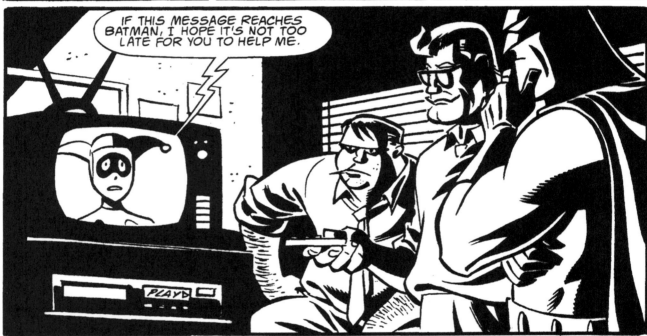

IF THIS MESSAGE REACHES BATMAN, I HOPE IT'S NOT TOO LATE FOR YOU TO HELP ME.

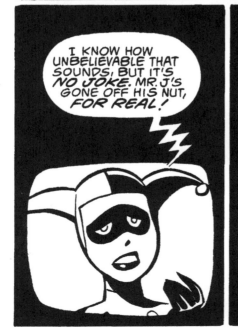

I KNOW HOW UNBELIEVABLE THAT SOUNDS, BUT IT'S *NO JOKE.* MR. J'S GONE OFF HIS NUT, *FOR REAL!*

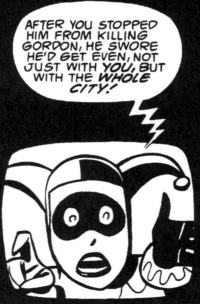

AFTER YOU STOPPED HIM FROM KILLING GORDON, HE SWORE HE'D GET EVEN, NOT JUST WITH *YOU,* BUT WITH THE *WHOLE CITY!*

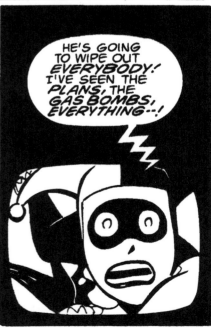

HE'S GOING TO WIPE OUT *EVERYBODY!* I'VE SEEN THE *PLANS,* THE *GAS BOMBS, EVERYTHING--!*

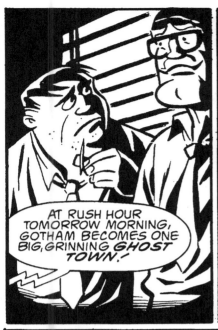

AT RUSH HOUR TOMORROW MORNING, GOTHAM BECOMES ONE BIG, GRINNING *GHOST TOWN!*

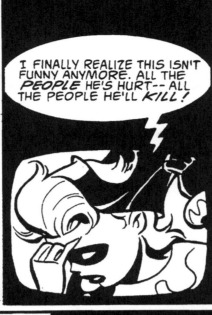

I FINALLY REALIZE THIS ISN'T FUNNY ANYMORE. ALL THE *PEOPLE* HE'S HURT-- ALL THE PEOPLE HE'LL *KILL!*

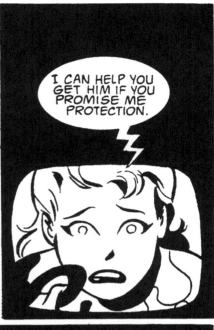

I CAN HELP YOU GET HIM IF YOU PROMISE ME PROTECTION.

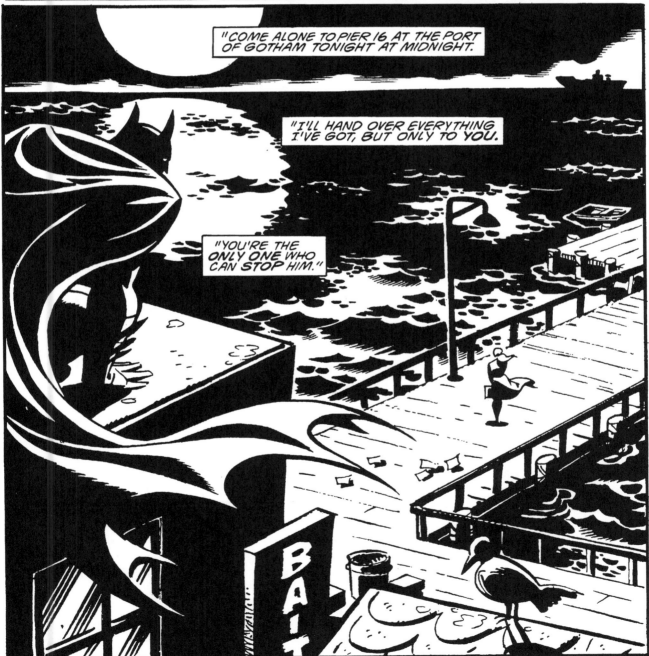

"COME ALONE TO PIER 16 AT THE PORT OF GOTHAM TONIGHT AT MIDNIGHT.

"I'LL HAND OVER EVERYTHING I'VE GOT, BUT ONLY TO *YOU.*

"YOU'RE THE ONLY ONE WHO CAN STOP HIM."

BAIT

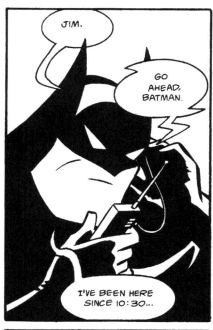

JIM.

GO AHEAD, BATMAN.

I'VE BEEN HERE SINCE 10:30...

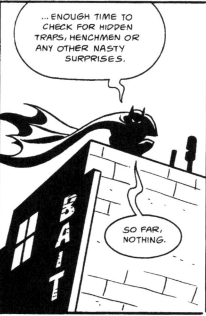

...ENOUGH TIME TO CHECK FOR HIDDEN TRAPS, HENCHMEN OR ANY OTHER NASTY SURPRISES.

SO FAR, NOTHING.

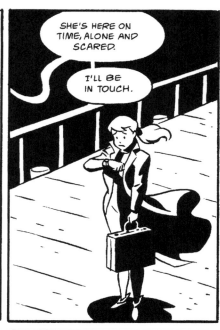

SHE'S HERE ON TIME, ALONE AND SCARED.

I'LL BE IN TOUCH.

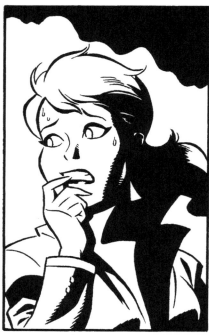

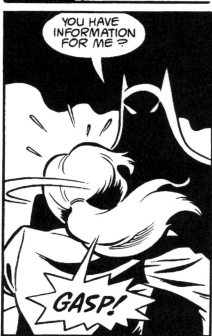

YOU HAVE INFORMATION FOR ME?

GASP!

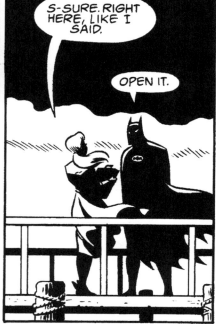

S-SURE. RIGHT HERE, LIKE I SAID.

OPEN IT.

YOU'RE THINKING BOOBY-TRAPS, RIGHT? WELL, I DON'T BLAME YOU, CONSIDERING.

OKAY?

I WANT GORDON TO SEE THESE. IF WHAT YOU SAY IS TRUE, THE POLICE WILL HAVE TO...

TRAITOR!!

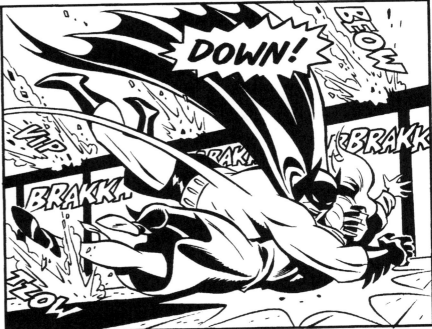

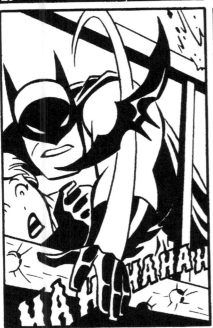

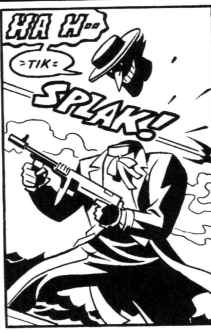

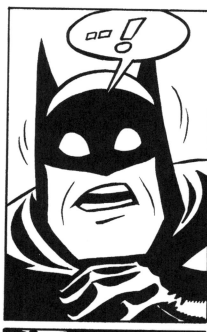

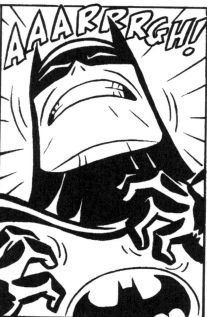

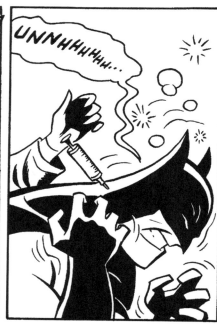

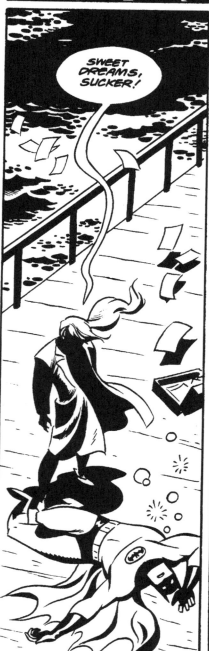

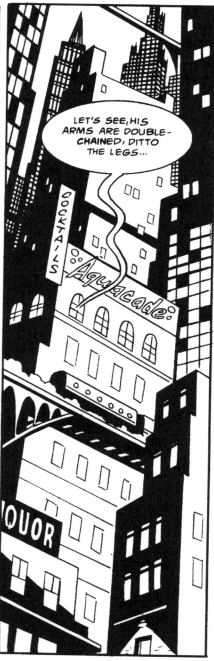

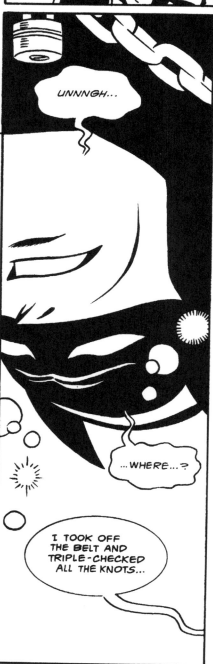

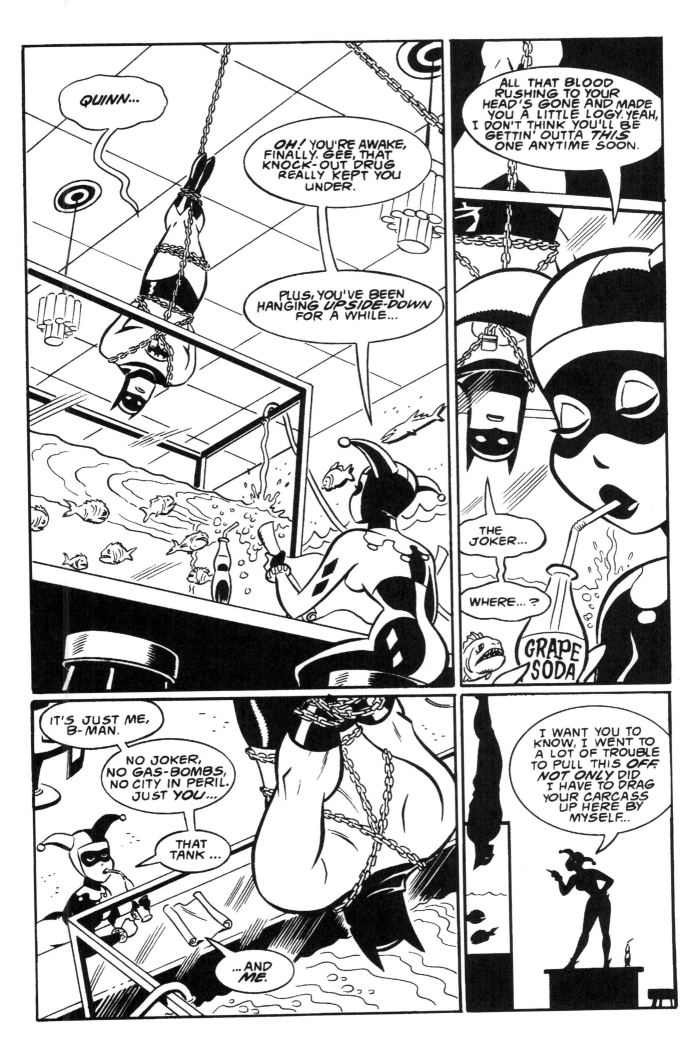

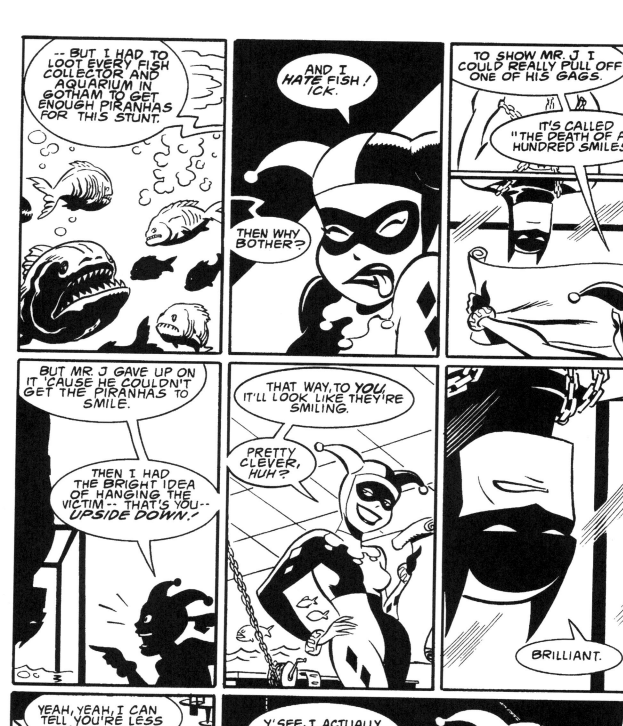

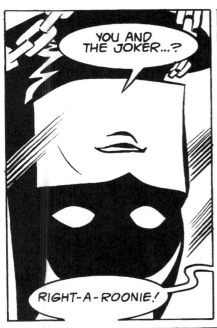

YOU AND THE JOKER...?

RIGHT-A-ROONIE!

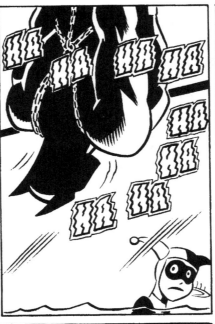

HA HA HA HA

HA HA

HA HA

HA HA

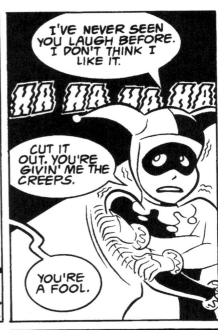

I'VE NEVER SEEN YOU LAUGH BEFORE. I DON'T THINK I LIKE IT.

HA HA HA HA

CUT IT OUT. YOU'RE GIVIN' ME THE CREEPS.

YOU'RE A FOOL.

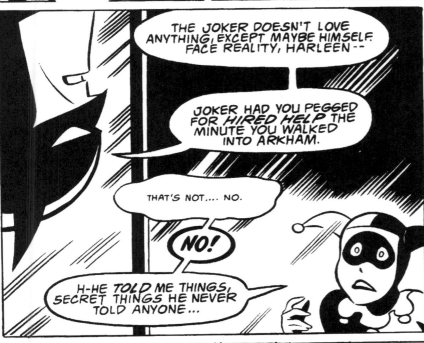

THE JOKER DOESN'T LOVE ANYTHING, EXCEPT MAYBE HIMSELF. FACE REALITY, HARLEEN--

JOKER HAD YOU PEGGED FOR *HIRED HELP* THE MINUTE YOU WALKED INTO ARKHAM.

THAT'S NOT.... NO.

NO!

H-HE *TOLD* ME THINGS, SECRET THINGS HE NEVER TOLD ANYONE...

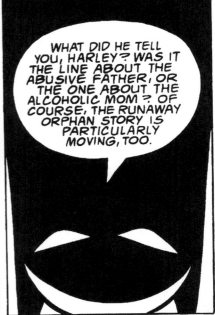

WHAT DID HE TELL YOU, HARLEY? WAS IT THE LINE ABOUT THE ABUSIVE FATHER, OR THE ONE ABOUT THE ALCOHOLIC MOM? OF COURSE, THE RUNAWAY ORPHAN STORY IS PARTICULARLY MOVING, TOO.

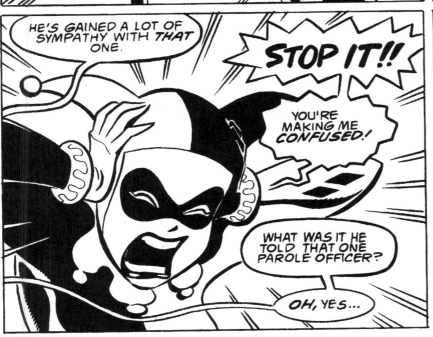

HE'S GAINED A LOT OF SYMPATHY WITH *THAT* ONE.

STOP IT!!

YOU'RE MAKING ME *CONFUSED!*

WHAT WAS IT HE TOLD THAT ONE PAROLE OFFICER?

OH, YES...

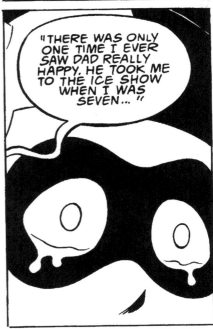

"THERE WAS ONLY ONE TIME I EVER SAW DAD REALLY HAPPY. HE TOOK ME TO THE ICE SHOW WHEN I WAS SEVEN..."

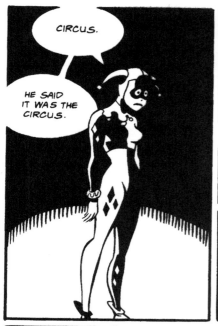

CIRCUS.

HE SAID IT WAS THE CIRCUS.

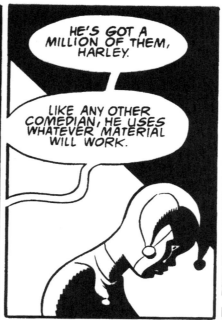

HE'S GOT A MILLION OF THEM, HARLEY.

LIKE ANY OTHER COMEDIAN, HE USES WHATEVER MATERIAL WILL WORK.

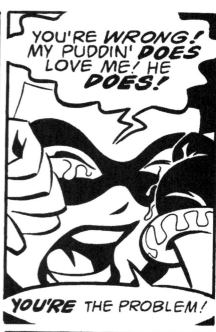

YOU'RE *WRONG!* MY PUDDIN' *DOES* LOVE ME! HE *DOES!*

YOU'RE THE PROBLEM!

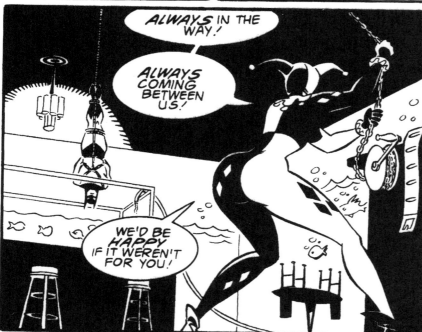

ALWAYS IN THE WAY!

ALWAYS COMING BETWEEN US!

WE'D BE *HAPPY* IF IT WEREN'T FOR YOU!

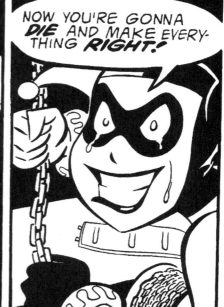

NOW YOU'RE GONNA *DIE* AND MAKE EVERY-THING *RIGHT!*

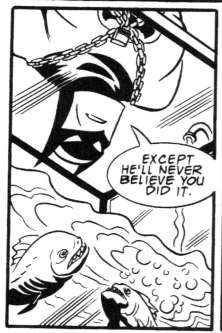

EXCEPT HE'LL NEVER BELIEVE YOU DID IT.

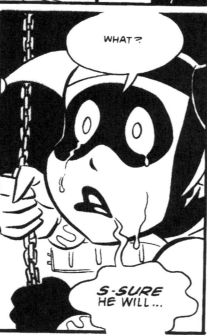

WHAT?

S-SURE HE WILL...

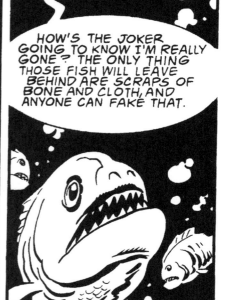

HOW'S THE JOKER GOING TO KNOW I'M REALLY GONE? THE ONLY THING THOSE FISH WILL LEAVE BEHIND ARE SCRAPS OF BONE AND CLOTH, AND ANYONE CAN FAKE THAT.

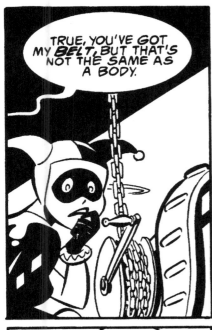

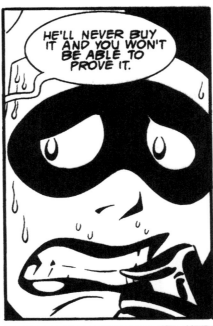

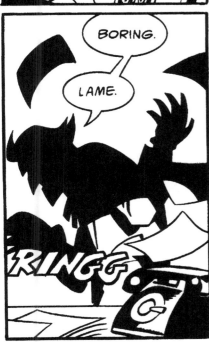

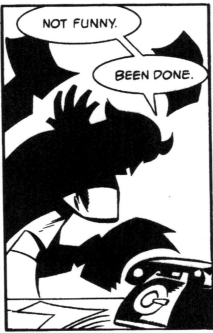

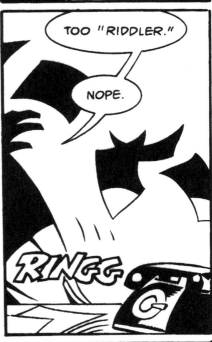

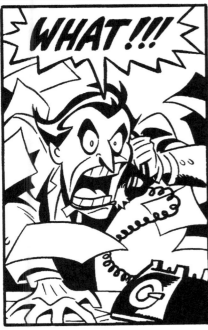

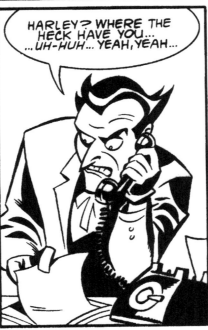

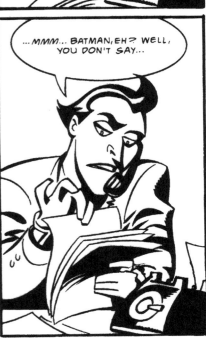

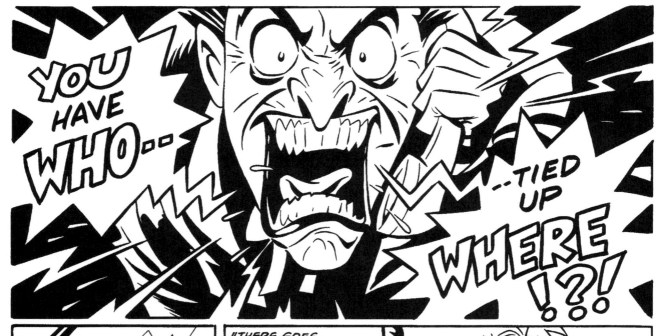

YOU HAVE WHO-- --TIED UP WHERE!?!

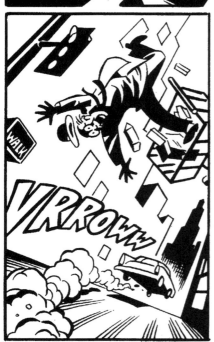

VRROWW

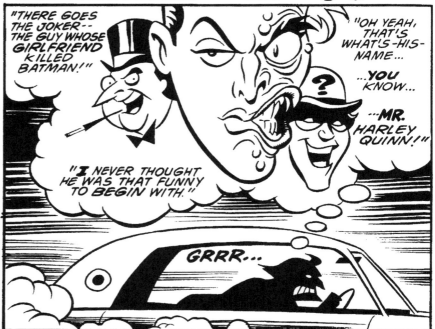

"THERE GOES THE JOKER-- THE GUY WHOSE GIRLFRIEND KILLED BATMAN!"

"OH YEAH, THAT'S WHAT'S-HIS-NAME... ...YOU KNOW... ...MR. HARLEY QUINN!"

"I NEVER THOUGHT HE WAS THAT FUNNY TO BEGIN WITH."

GRRR...

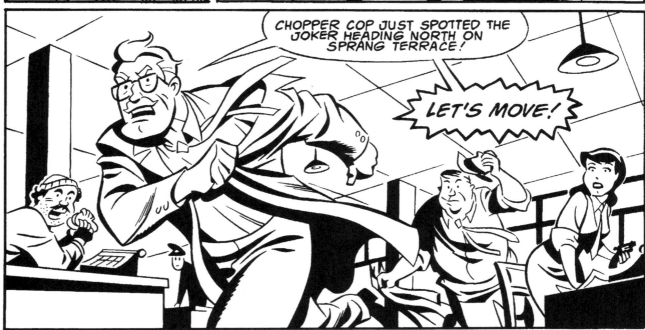

CHOPPER COP JUST SPOTTED THE JOKER HEADING NORTH ON SPRANG TERRACE!

LET'S MOVE!

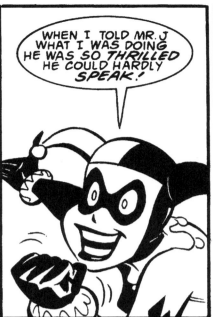

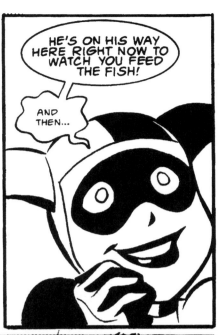

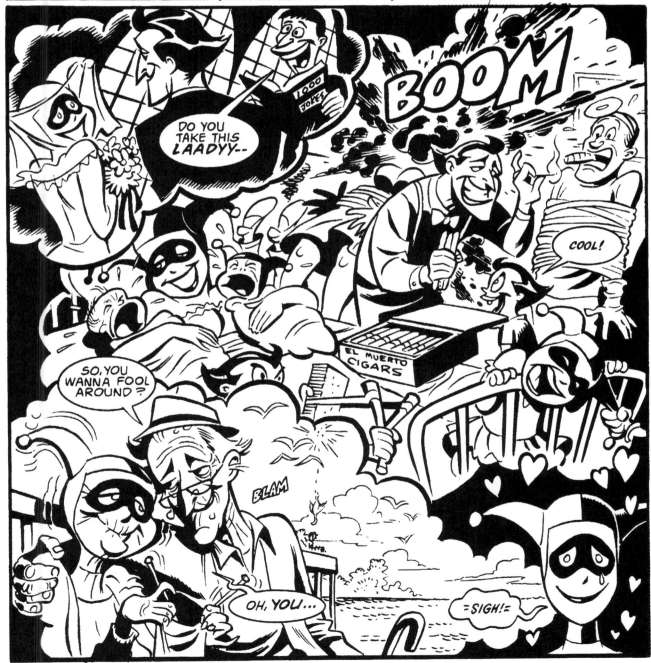

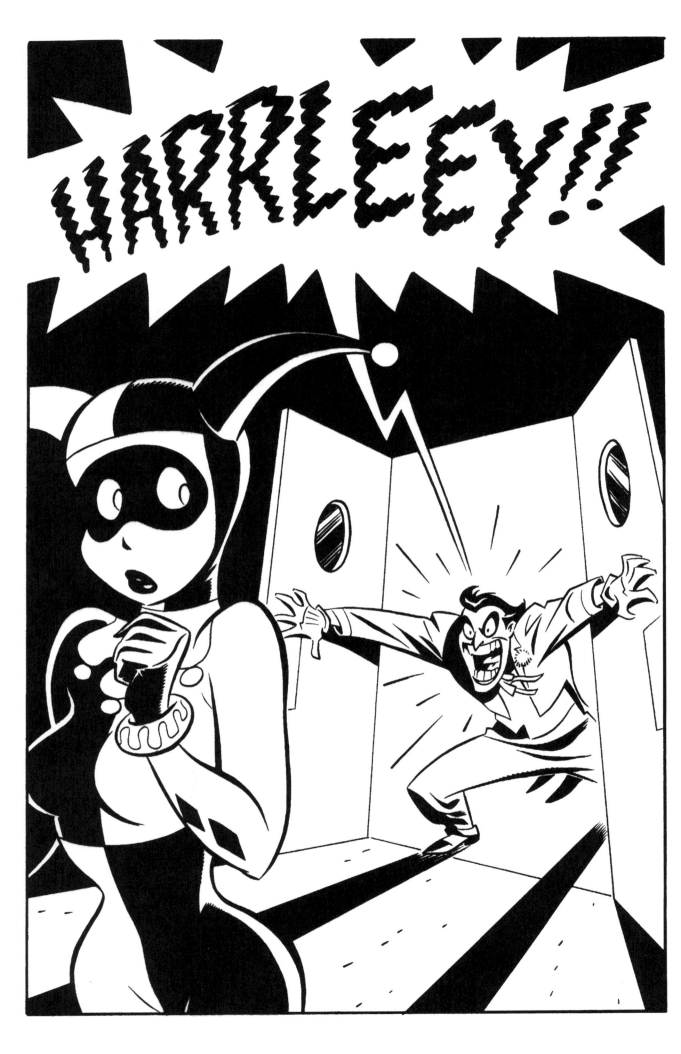

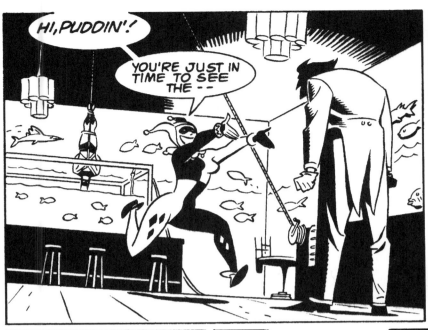
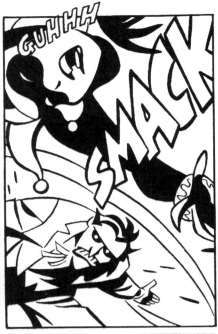

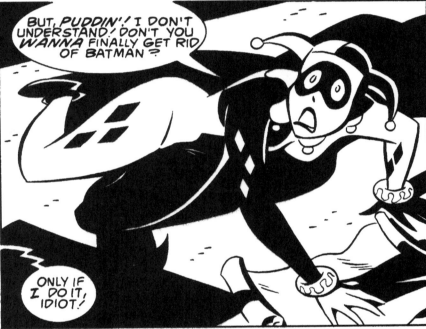
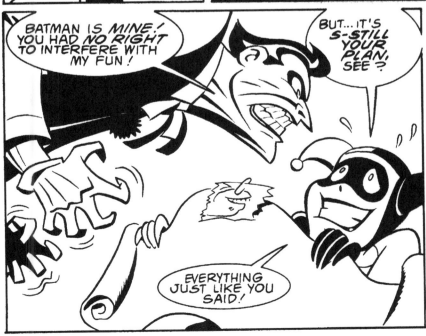
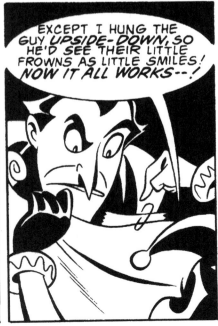

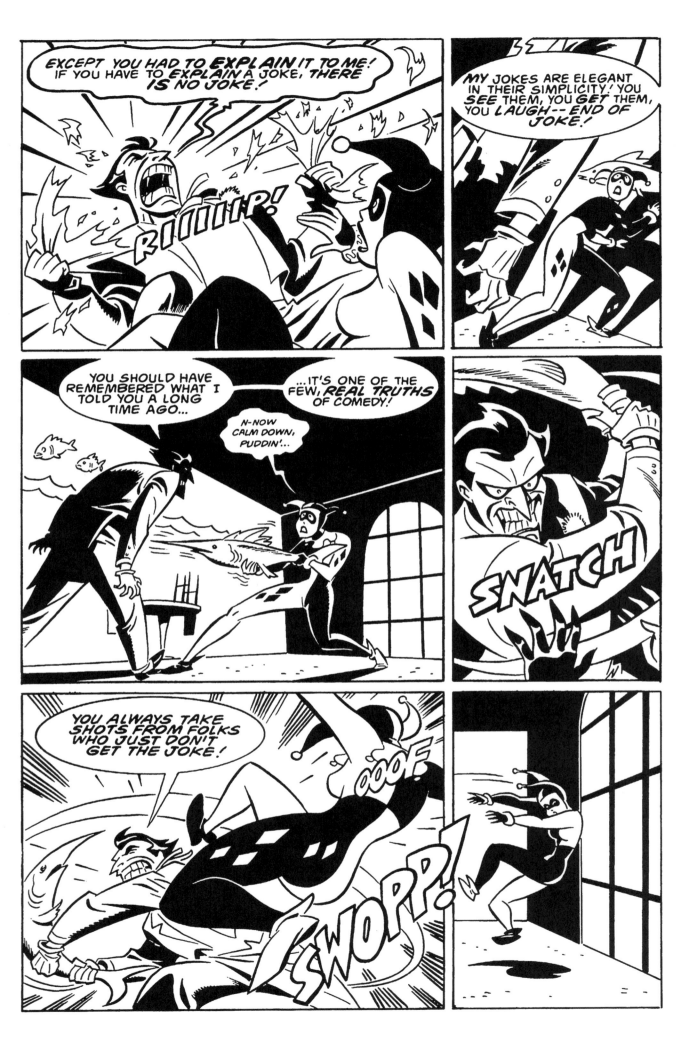

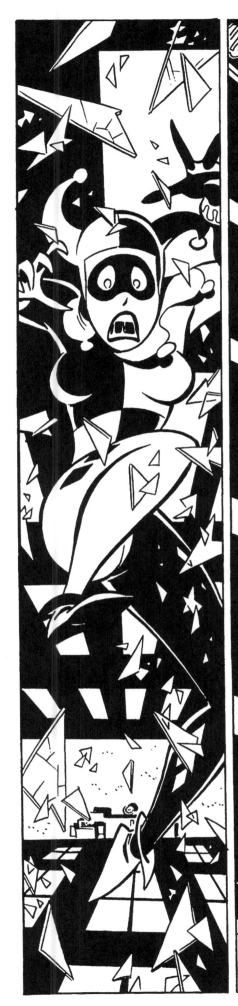

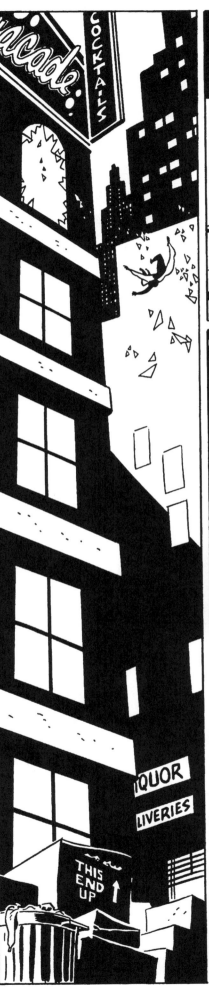

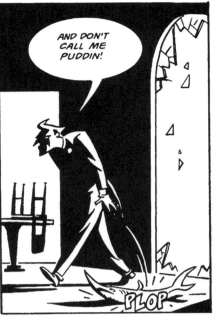

AND DON'T CALL ME PUDDIN!

PLOP.

LAST REPORT SAID JOKER WAS HEADED THIS WAY...

COMMISSIONER! IN THE ALLEY!

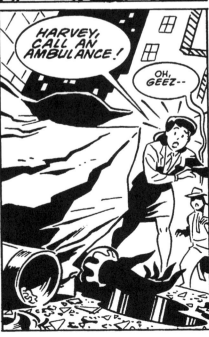

HARVEY, CALL AN AMBULANCE!

OH, GEEZ--

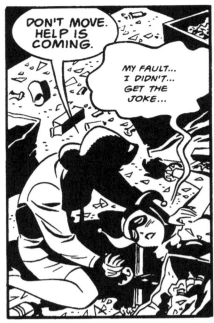

DON'T MOVE. HELP IS COMING.

MY FAULT... I DIDN'T... GET THE JOKE...

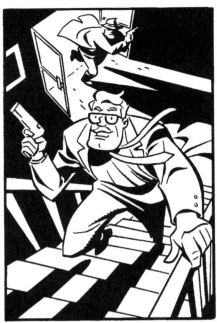

I *REALLY* HAVE TO APOLOGIZE FOR THE *KID!*

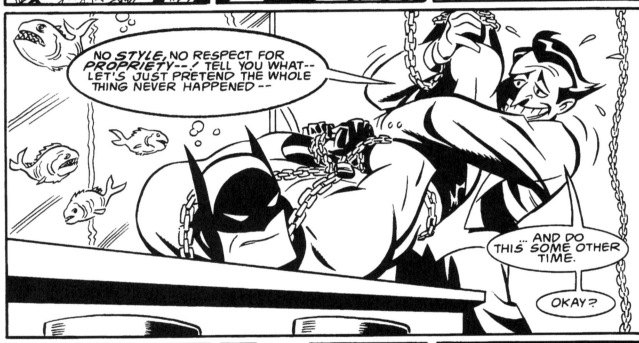

NO *STYLE*, NO RESPECT FOR *PROPRIETY--!* TELL YOU WHAT-- LET'S JUST PRETEND THE WHOLE THING NEVER HAPPENED --

...AND DO THIS SOME OTHER TIME.

OKAY?

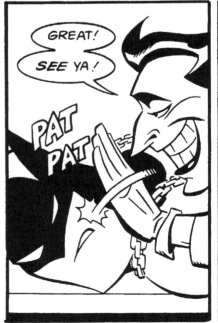

GREAT! SEE YA!

PAT PAT

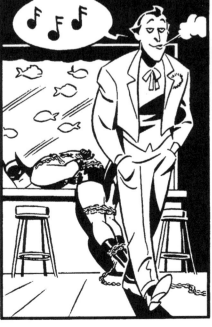

♪ ♪ ♪

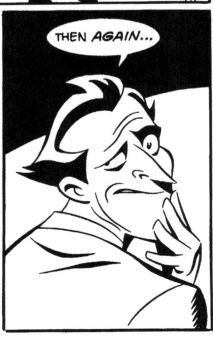

THEN *AGAIN*...

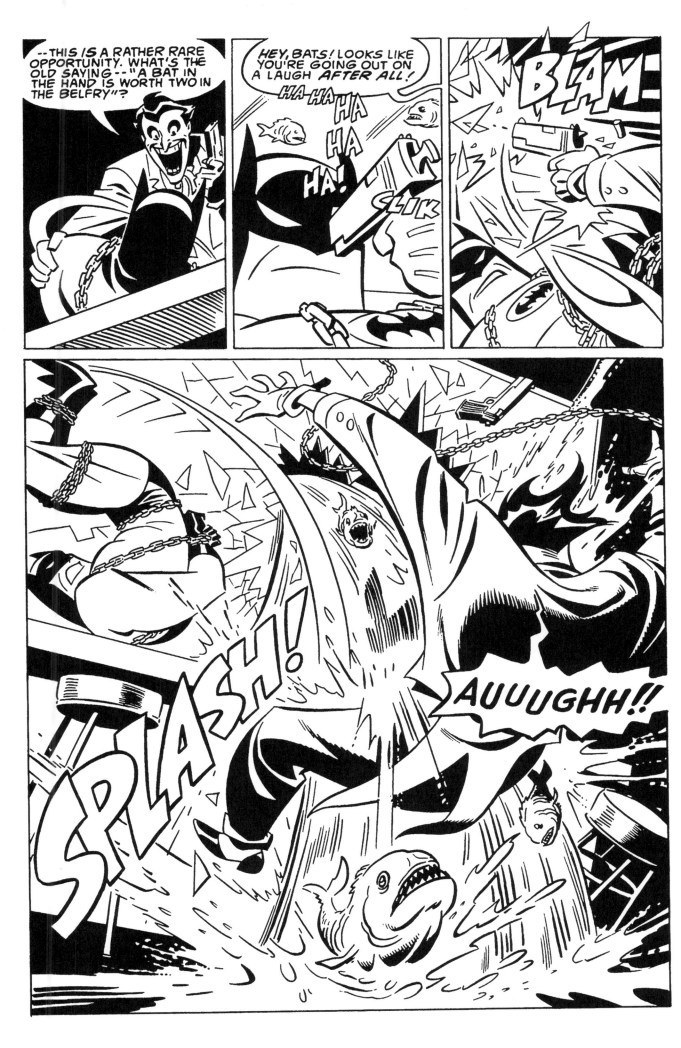

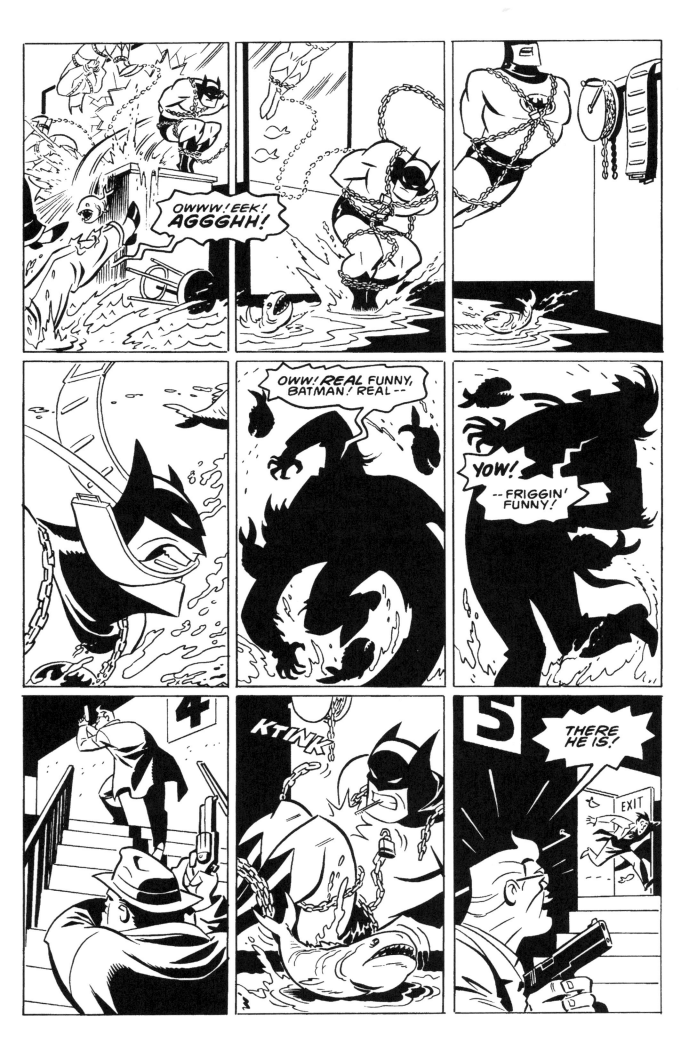

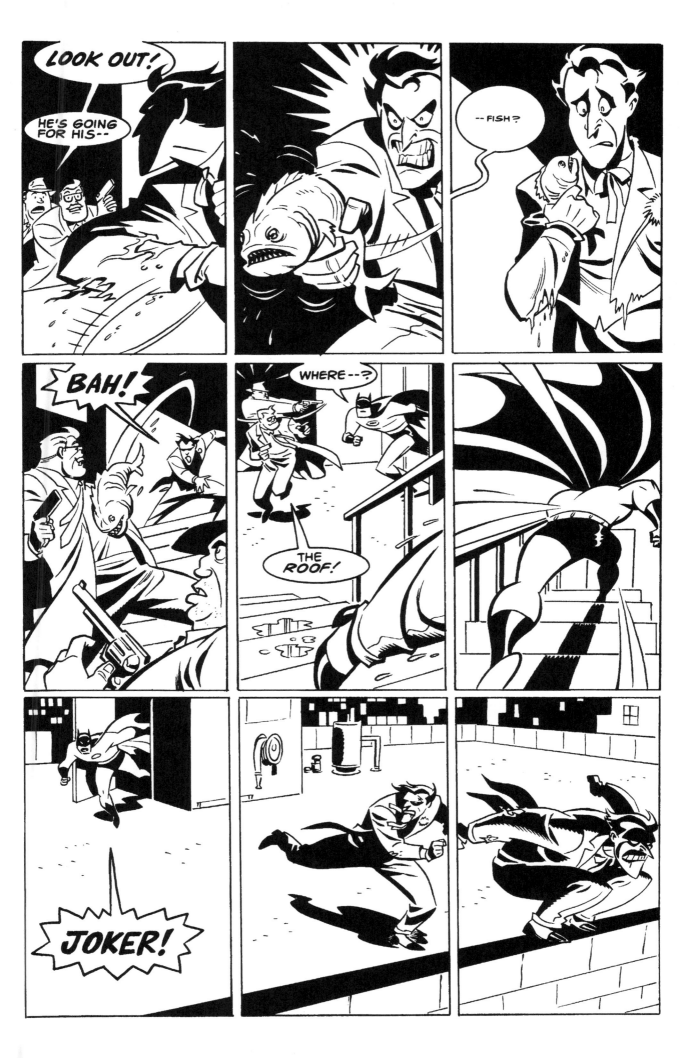

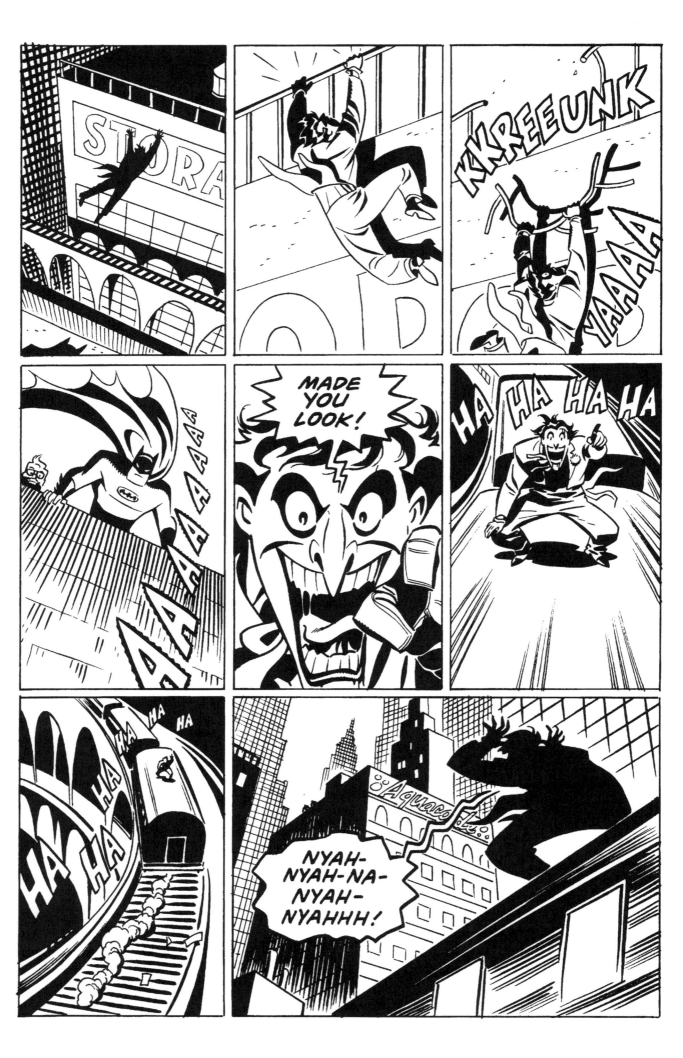

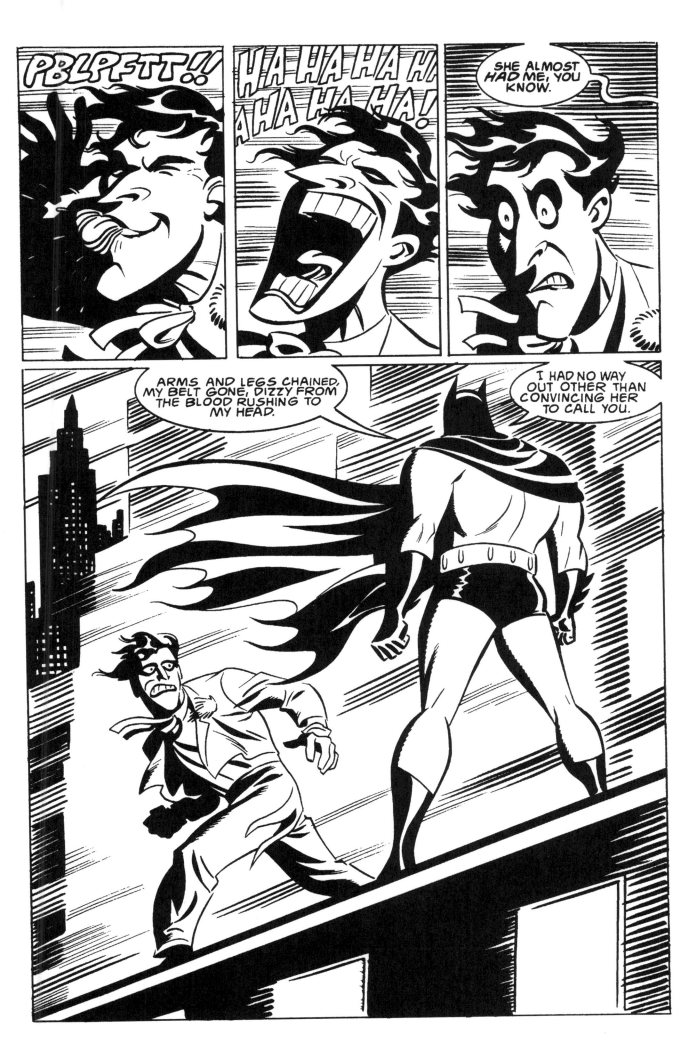

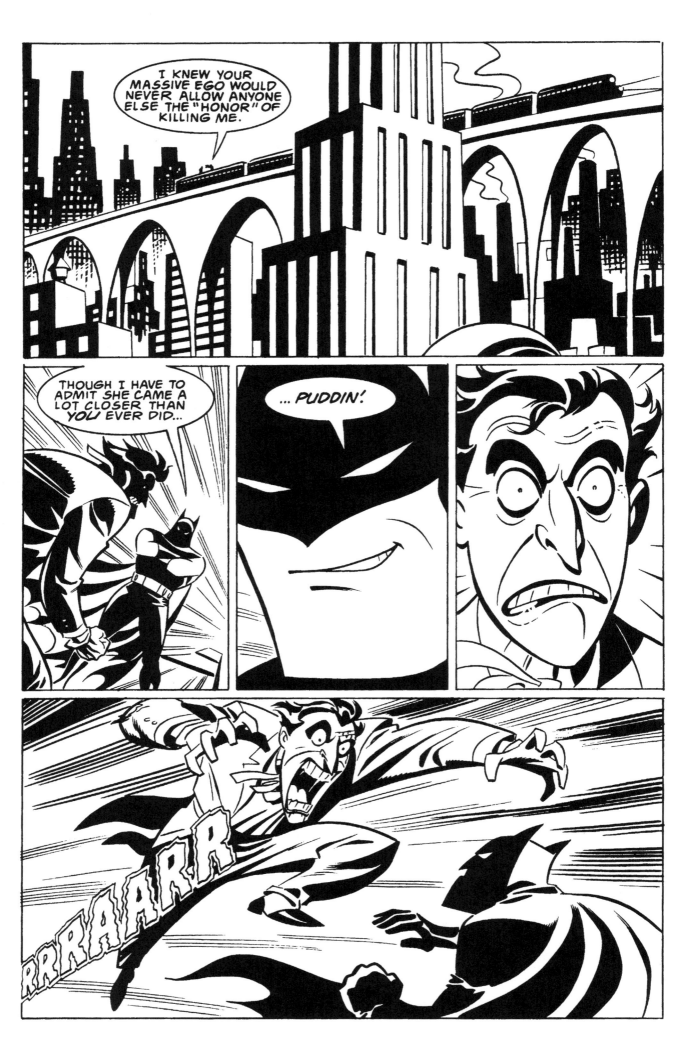

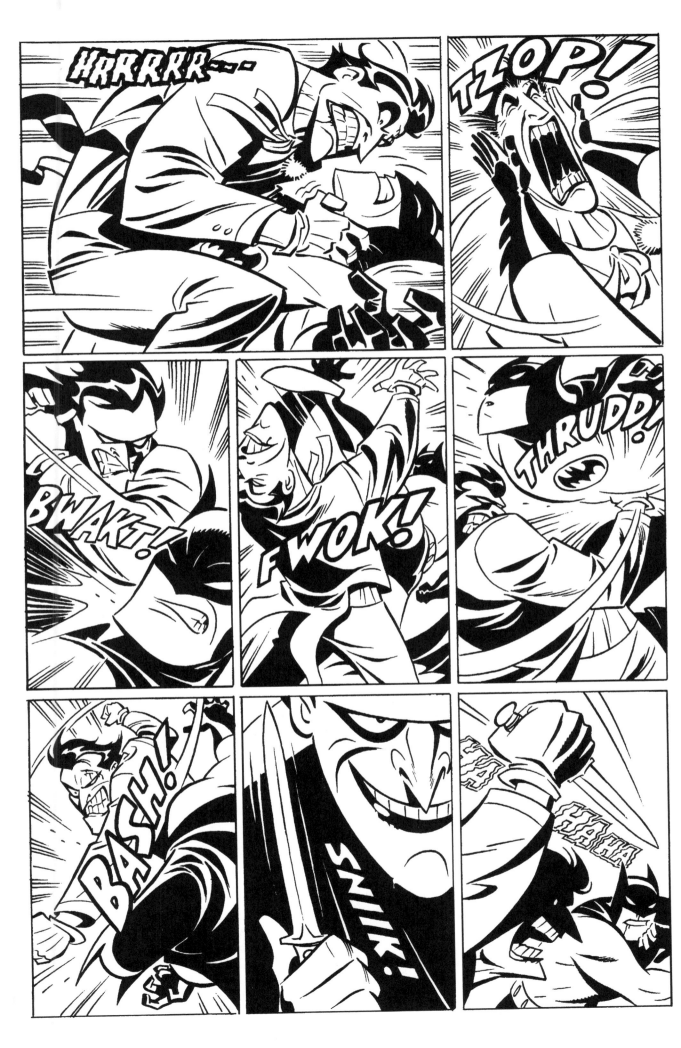

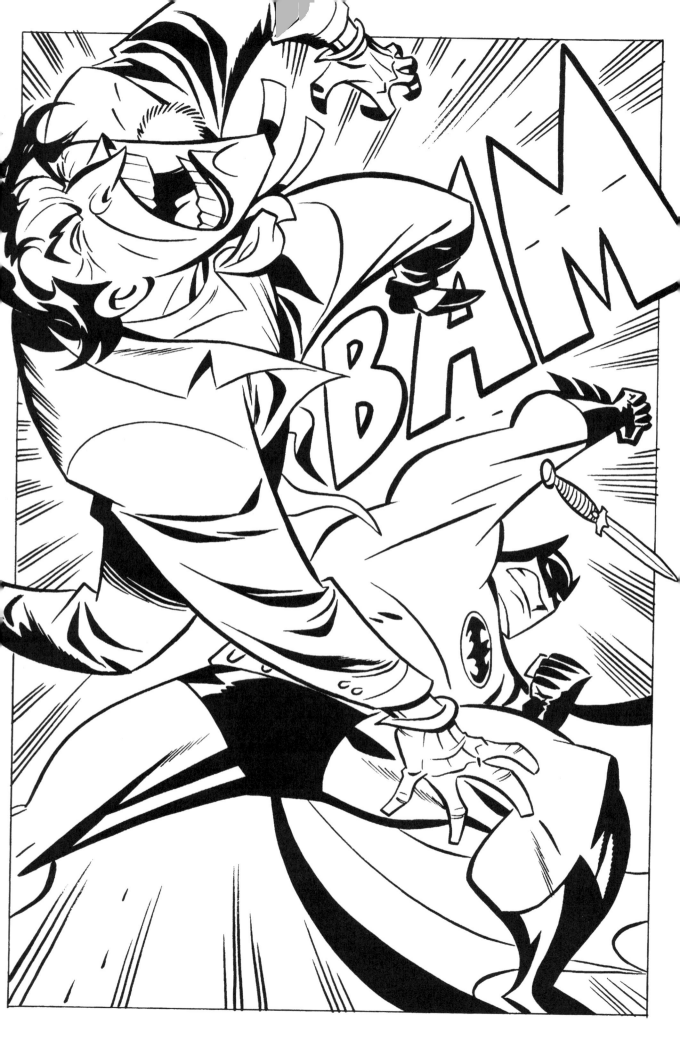

OH, NO...

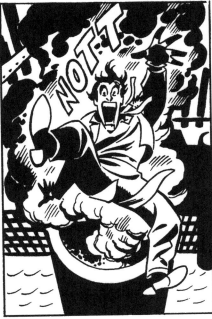

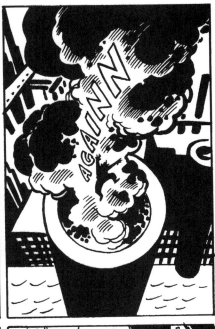

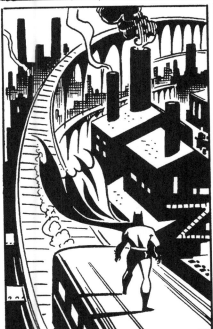

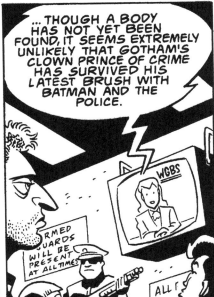

...THOUGH A BODY HAS NOT YET BEEN FOUND, IT SEEMS EXTREMELY UNLIKELY THAT GOTHAM'S CLOWN PRINCE OF CRIME HAS SURVIVED HIS LATEST BRUSH WITH BATMAN AND THE POLICE.

WGBS

RMED GUARDS WILL BE PRESENT AT ALL TIMES

ALL REM SEATS

STILL, HE HAS BEEN NOTORIOUS FOR RESURFACING WHEN LEAST EXPECTED...

NEVER AGAIN.

RECREATION THERAPY

NO MORE OBSESSION.

NO MORE CRAZINESS.

NO MORE JOKER.

I FINALLY SEE THAT SLIME FOR WHAT HE REALLY IS.

I'LL SERVE MY TIME PEACEFULLY, HEAL MYSELF AND GET OUT OF HERE.

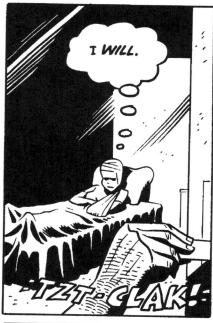

I WILL.

-TZT-CLAK!

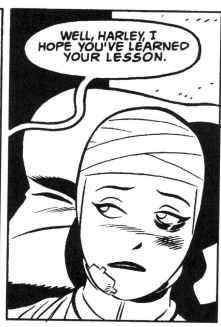

WELL, HARLEY, I HOPE YOU'VE LEARNED YOUR LESSON.

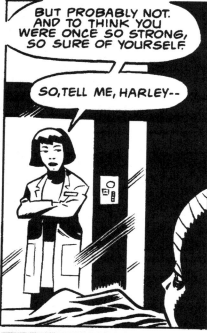

BUT PROBABLY NOT. AND TO THINK YOU WERE ONCE SO STRONG, SO SURE OF YOURSELF.

SO, TELL ME, HARLEY--

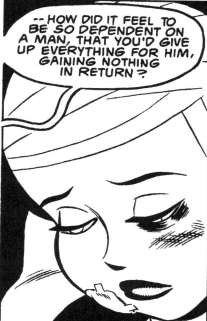

-- HOW DID IT FEEL TO BE SO DEPENDENT ON A MAN, THAT YOU'D GIVE UP EVERYTHING FOR HIM, GAINING NOTHING IN RETURN?

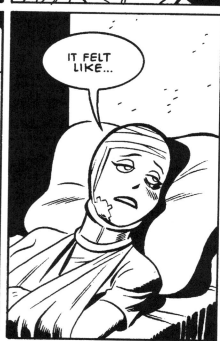

IT FELT LIKE...

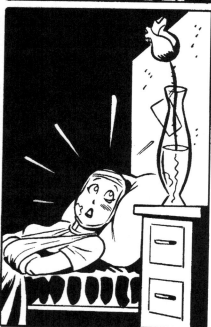

FEEL BETTER SOON. — J.

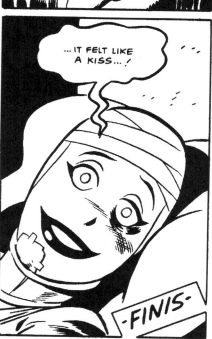

...IT FELT LIKE A KISS...!

-FINIS-

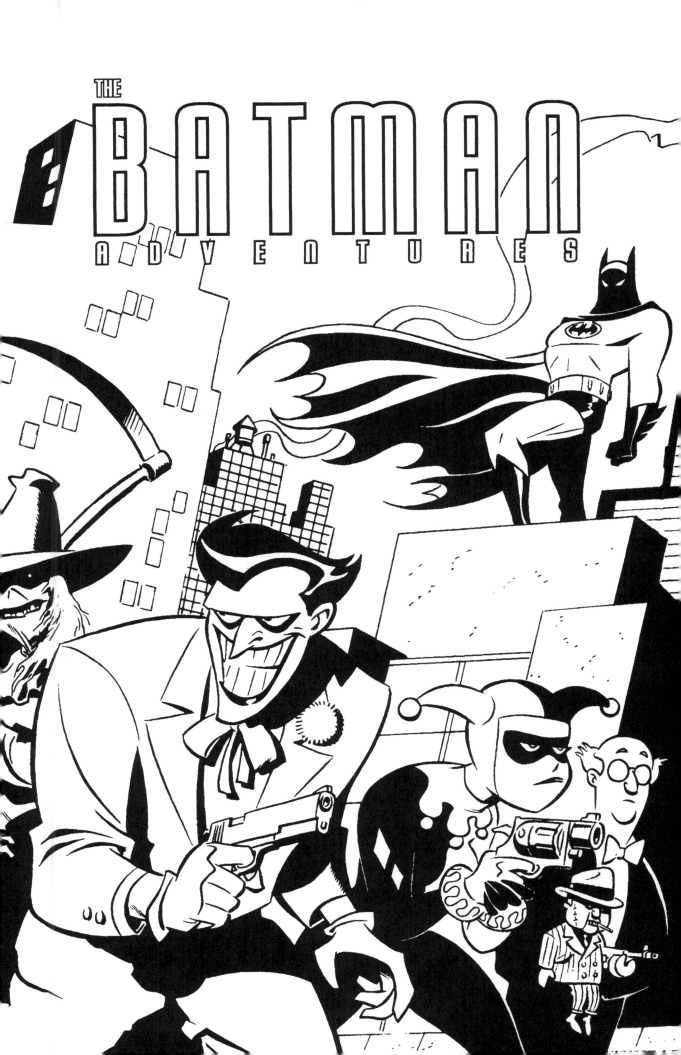

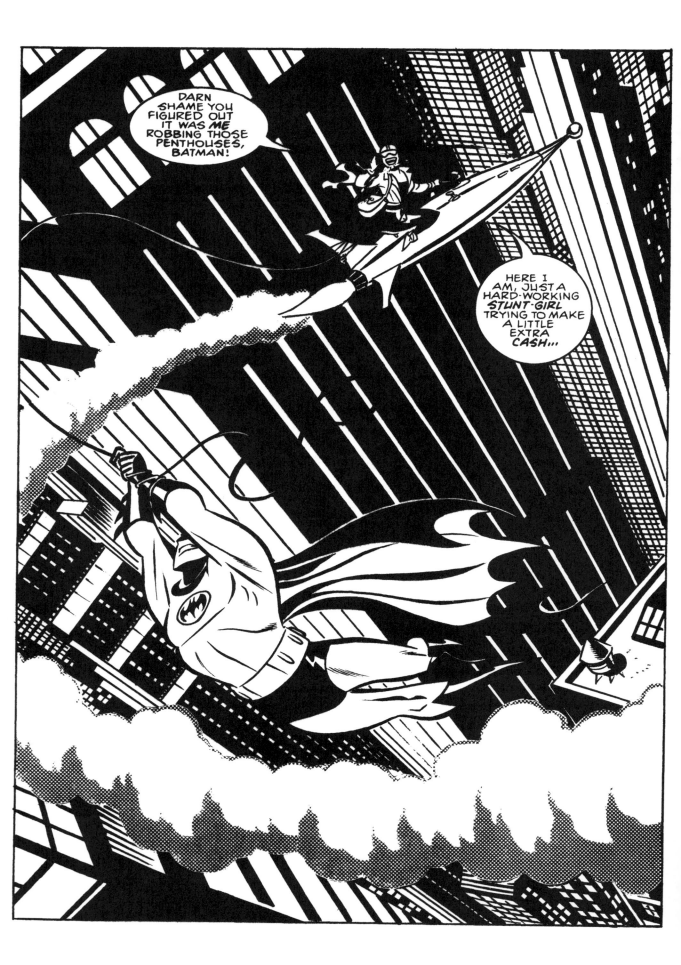

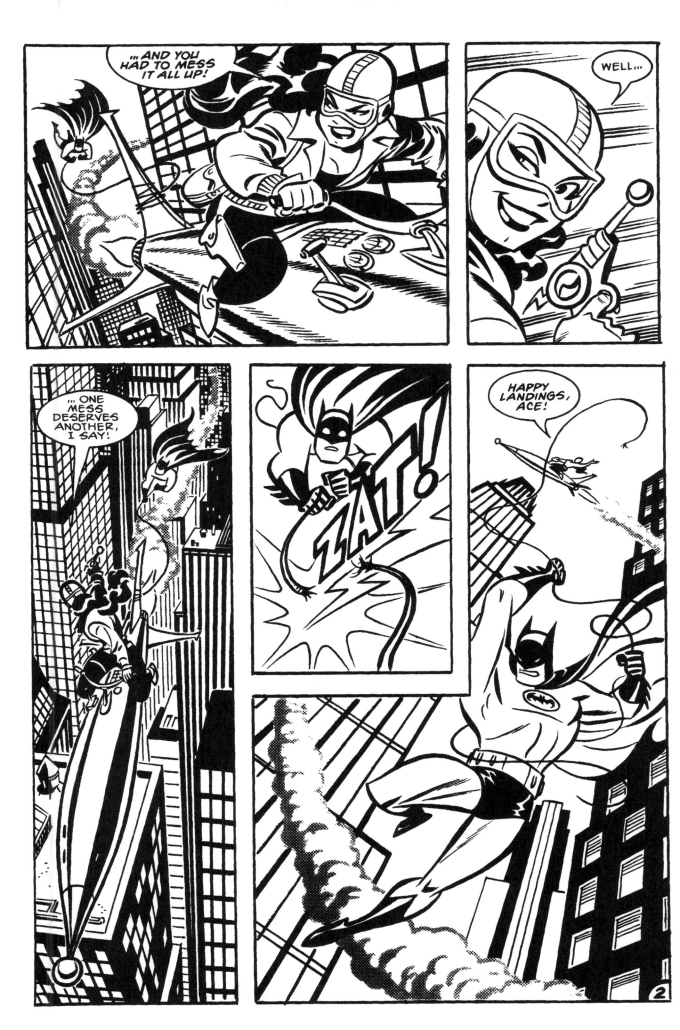

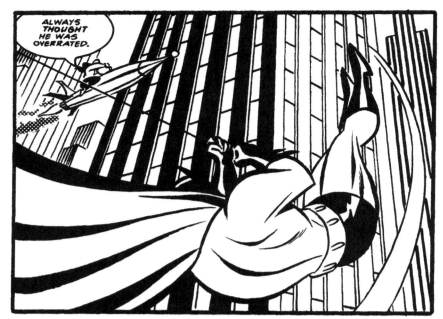

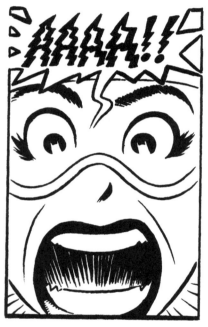

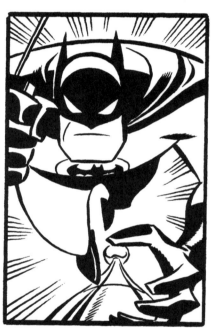

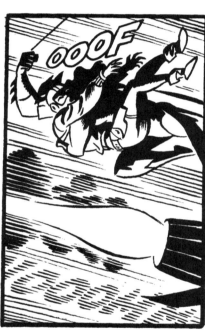

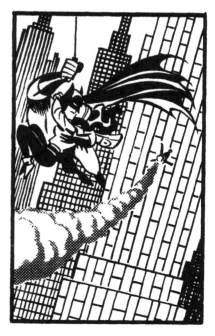

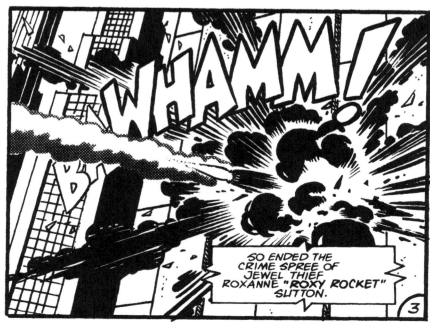

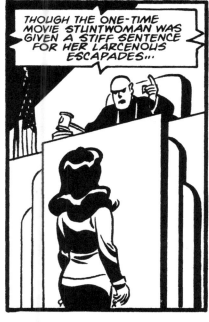

THOUGH THE ONE-TIME MOVIE STUNTWOMAN WAS GIVEN A STIFF SENTENCE FOR HER LARCENOUS ESCAPADES...

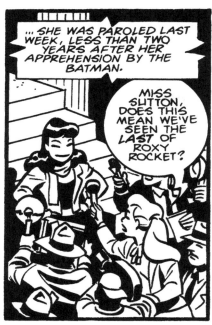

...SHE WAS PAROLED LAST WEEK, LESS THAN TWO YEARS AFTER HER APPREHENSION BY THE BATMAN.

MISS SUTTON, DOES THIS MEAN WE'VE SEEN THE *LAST* OF ROXY ROCKET?

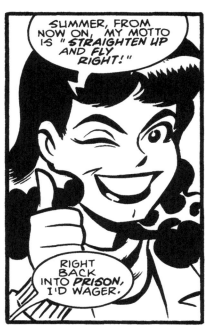

SUMMER, FROM NOW ON, MY MOTTO IS *"STRAIGHTEN UP AND FLY RIGHT!"*

RIGHT BACK INTO *PRISON*, I'D WAGER.

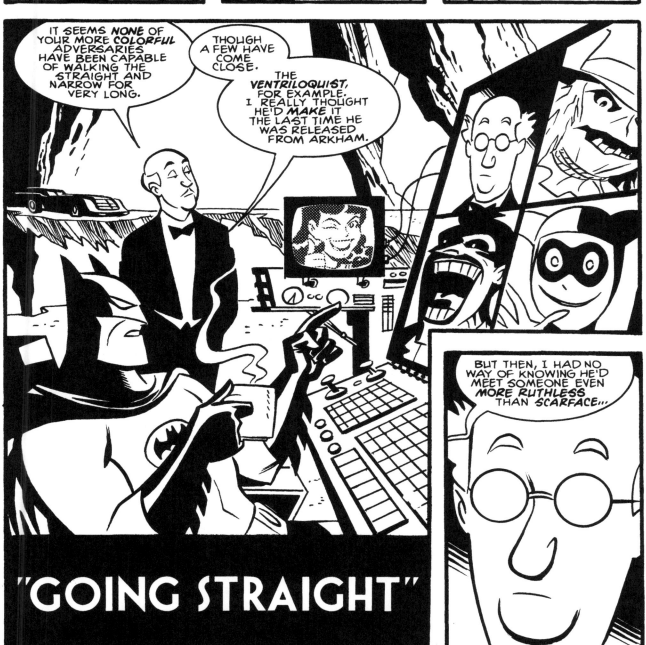

IT SEEMS *NONE* OF YOUR MORE *COLORFUL* ADVERSARIES HAVE BEEN CAPABLE OF WALKING THE STRAIGHT AND NARROW FOR VERY LONG.

THOUGH A FEW HAVE COME CLOSE.

THE *VENTRILOQUIST*, FOR EXAMPLE. I REALLY THOUGHT HE'D *MAKE* IT THE LAST TIME HE WAS RELEASED FROM ARKHAM.

BUT THEN, I HAD NO WAY OF KNOWING HE'D MEET SOMEONE EVEN *MORE RUTHLESS* THAN *SCARFACE...*

"GOING STRAIGHT"

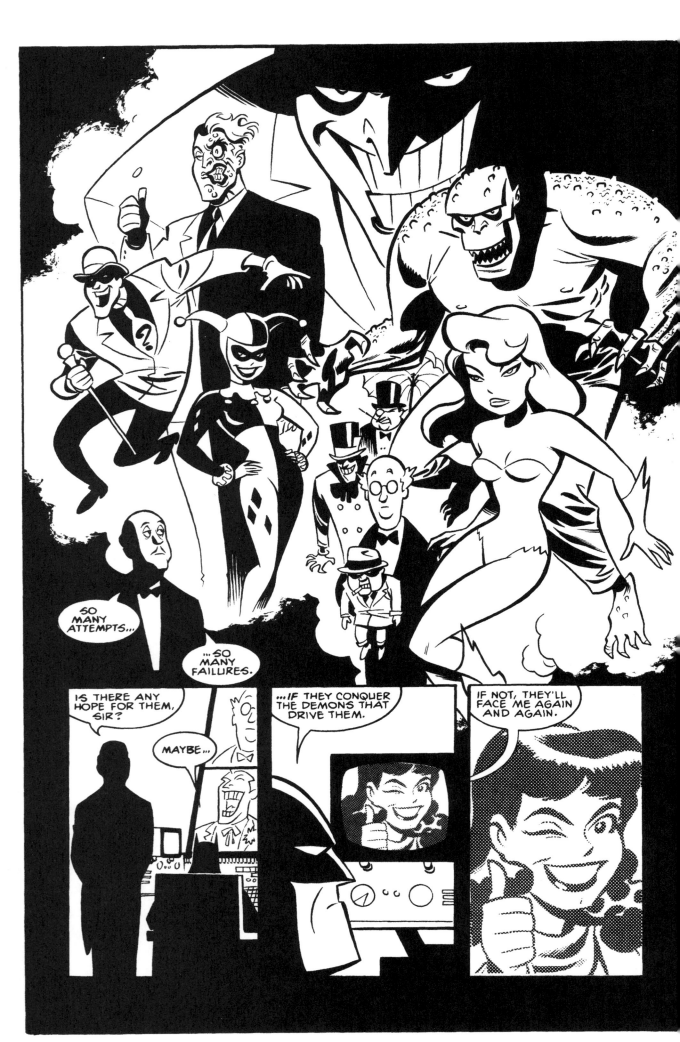

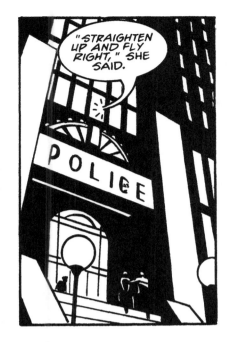

"STRAIGHTEN UP AND FLY RIGHT," SHE SAID.

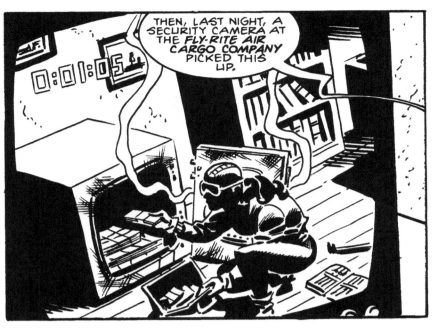

THEN, LAST NIGHT, A SECURITY CAMERA AT THE *FLY-RITE AIR CARGO COMPANY* PICKED THIS UP.

0:01:05

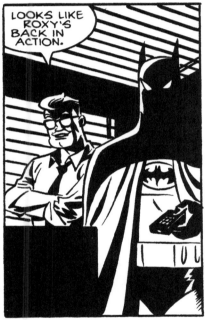

LOOKS LIKE ROXY'S BACK IN ACTION.

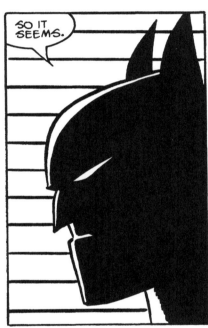

SO IT SEEMS.

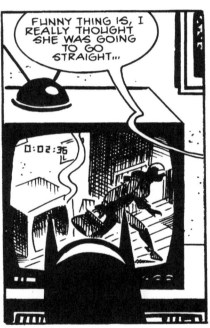

FUNNY THING IS, I REALLY THOUGHT SHE WAS GOING TO GO STRAIGHT...

0:02:36

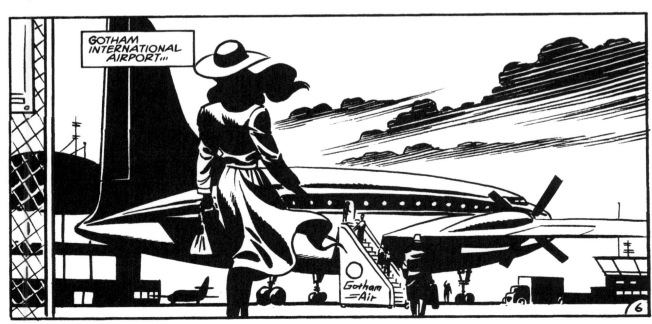

GOTHAM INTERNATIONAL AIRPORT...

Gotham Air

6

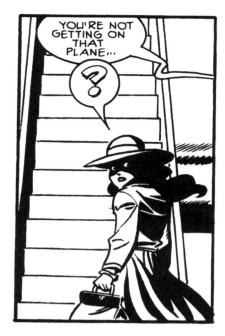

YOU'RE NOT GETTING ON THAT PLANE...

?

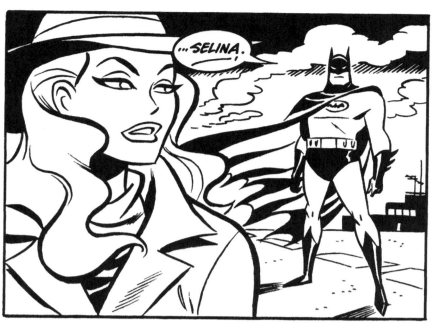

...SELINA.

HOW DID YOU KNOW IT WAS ME?

I SAW THE SECURITY TAPE. YOU MIGHT HAVE BORROWED ROXY'S LOOK, BUT YOUR BODY LANGUAGE WAS PURE CATWOMAN.

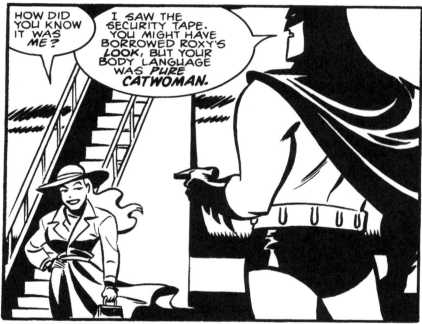

AND HERE I THOUGHT ALL YOU EVER NOTICED WERE MY EYES.

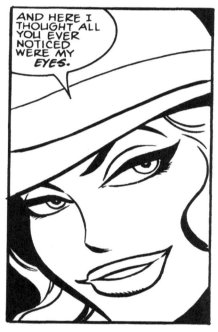

I'LL TRY TO BE LESS OBVIOUS IN THE FUTURE!

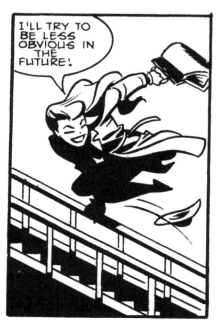

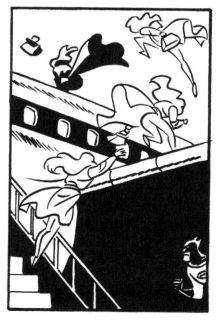

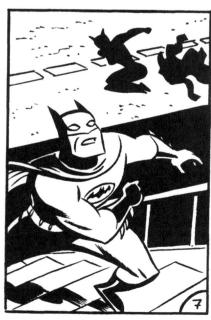

7

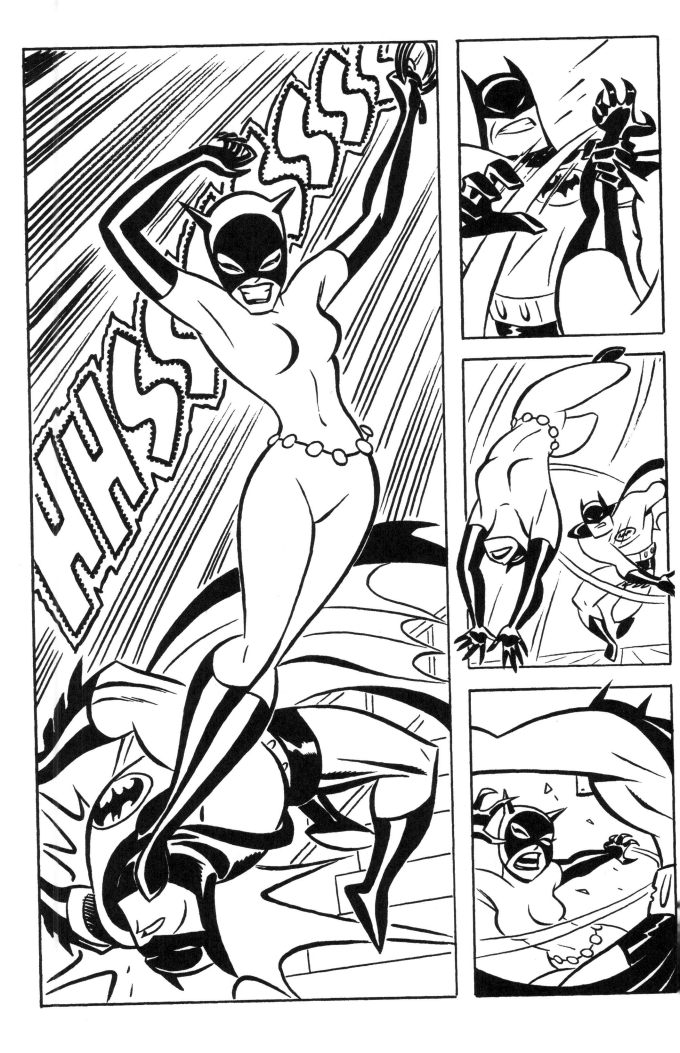

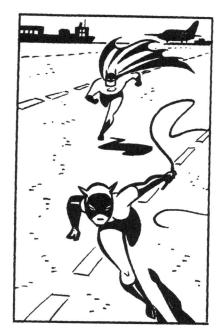

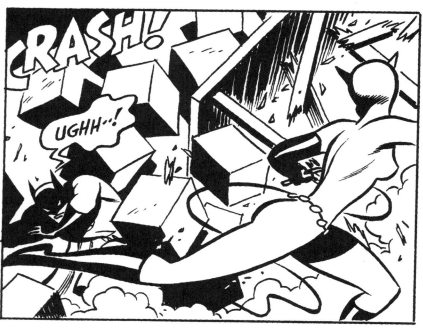
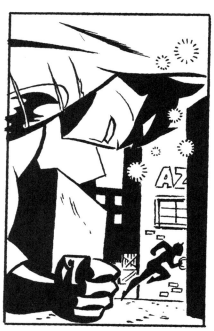
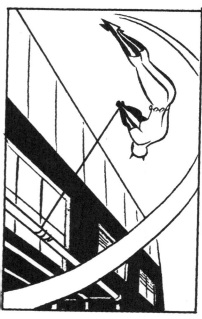
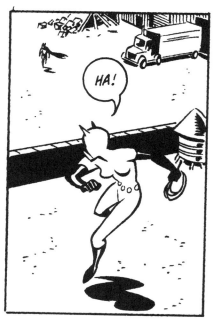

9

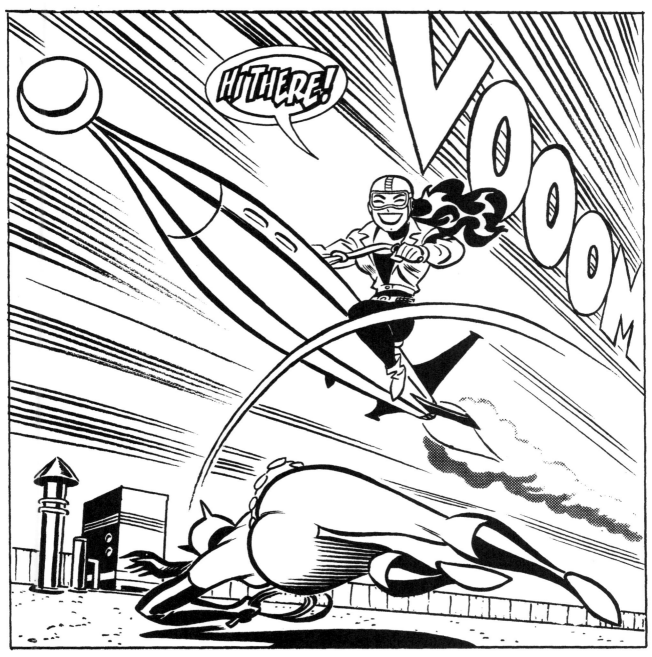

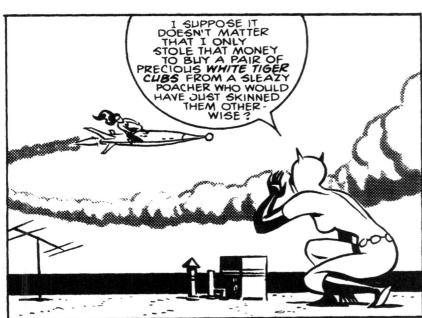

10

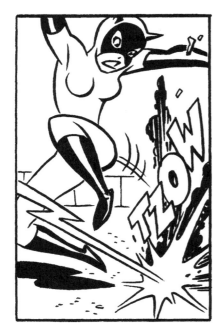

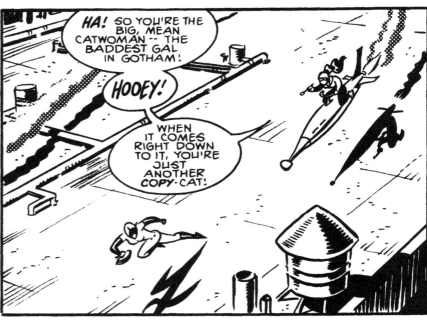

HA! SO YOU'RE THE BIG, MEAN CATWOMAN -- THE BADDEST GAL IN GOTHAM!

HOOEY!

WHEN IT COMES RIGHT DOWN TO IT, YOU'RE JUST ANOTHER COPY-CAT!

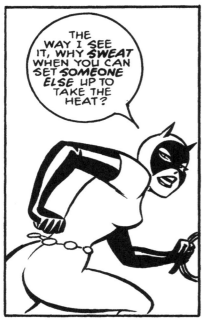

THE WAY I SEE IT, WHY SWEAT WHEN YOU CAN SET SOMEONE ELSE UP TO TAKE THE HEAT?

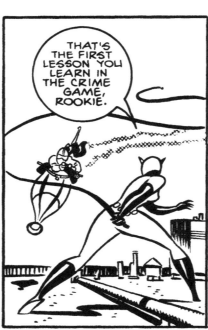

THAT'S THE FIRST LESSON YOU LEARN IN THE CRIME GAME, ROOKIE.

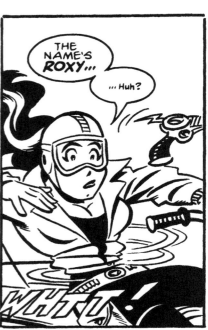

THE NAME'S ROXY...

...HUH?

WHTU

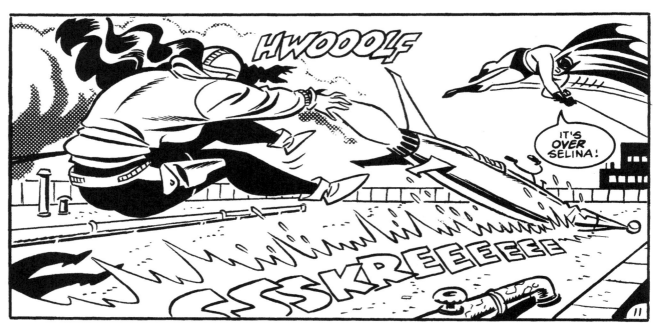

HWOOOLF

IT'S OVER SELINA!

SSSKREEEEE

11

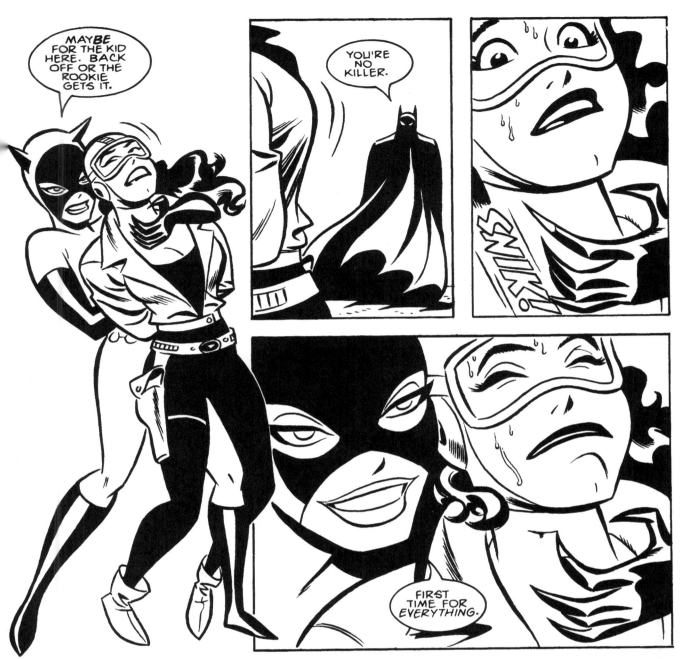

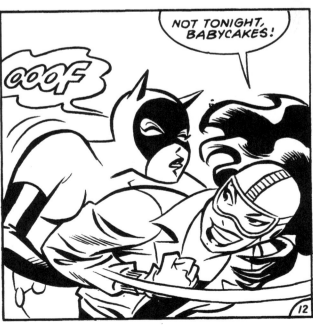

12

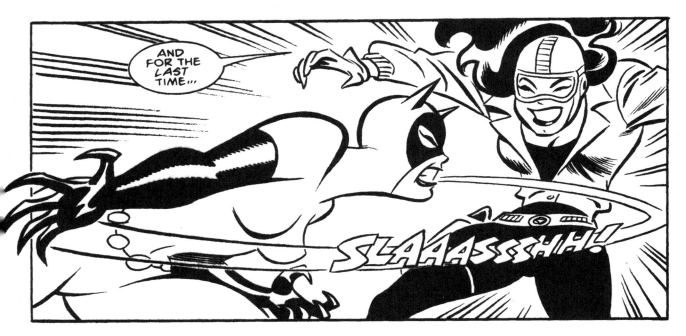

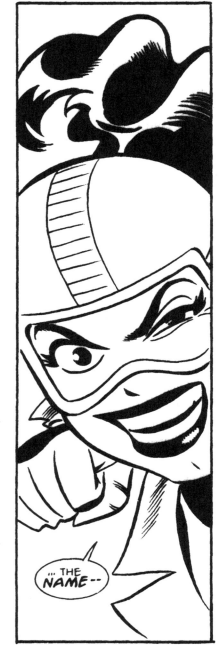

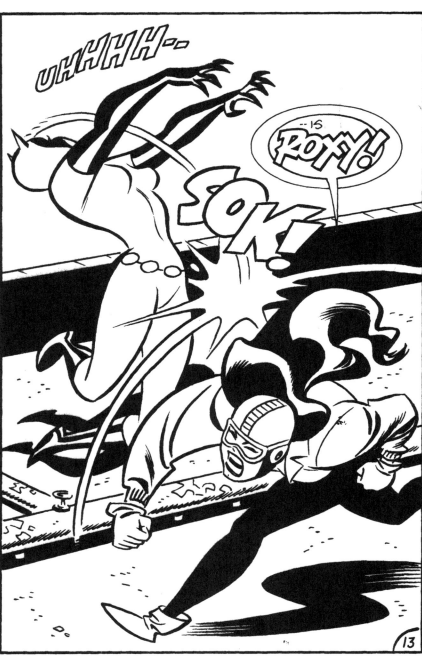

13

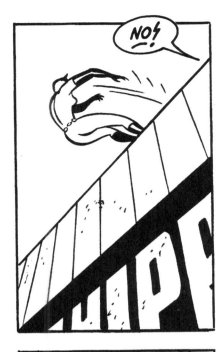

NO!

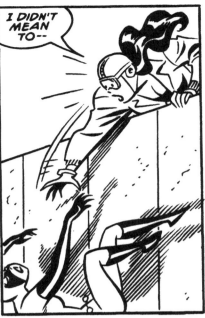

I DIDN'T MEAN TO--

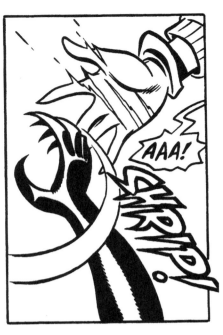

AAA!

SHRIP!

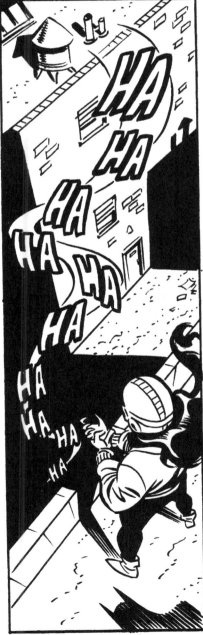

HA HA HA HA HA HA HA HA -HA -HA -HA

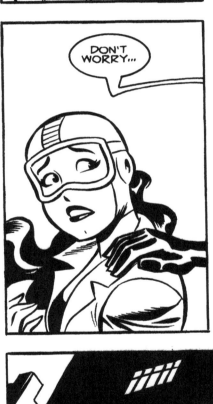

DON'T WORRY...

SHE'S GOT AT LEAST EIGHT MORE LIVES...

SSHHIIPPIN

14

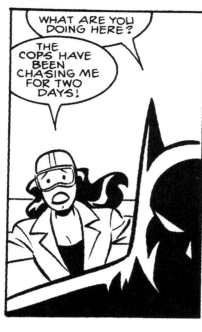

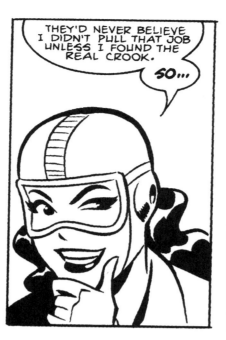

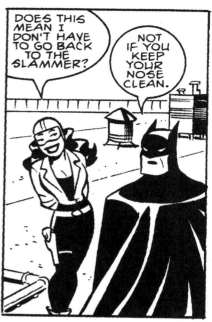

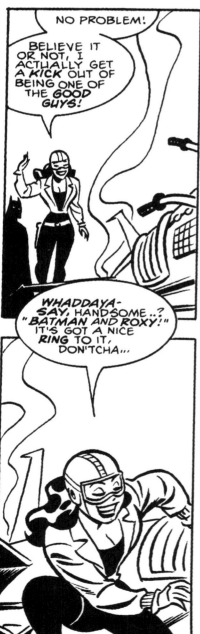

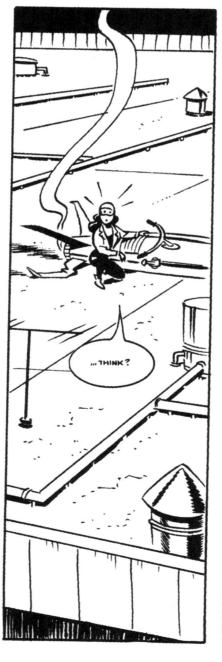

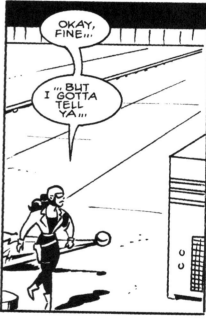

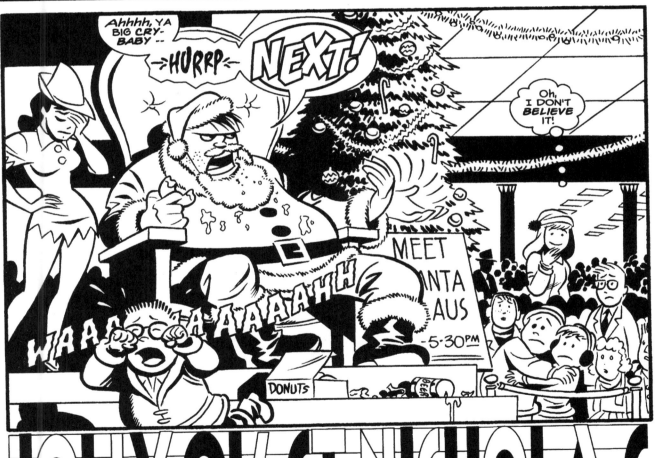

JOLLY OL' ST. NICHOLAS

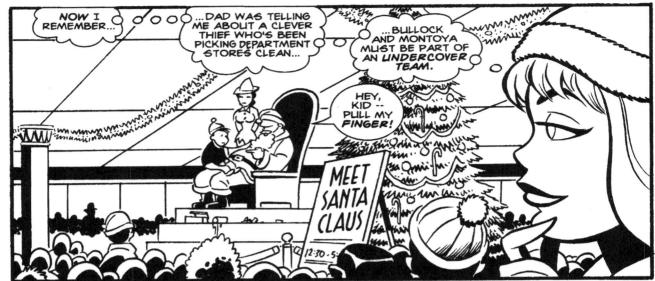

NOW I REMEMBER...

...DAD WAS TELLING ME ABOUT A CLEVER THIEF WHO'S BEEN PICKING DEPARTMENT STORES CLEAN...

...BULLOCK AND MONTOYA MUST BE PART OF AN *UNDERCOVER* TEAM.

HEY, KID -- PULL MY *FINGER!*

MEET SANTA CLAUS

12:30·5·

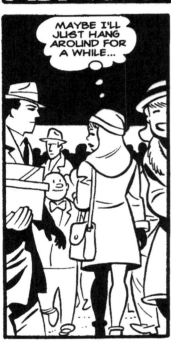

MAYBE I'LL JUST HANG AROUND FOR A WHILE...

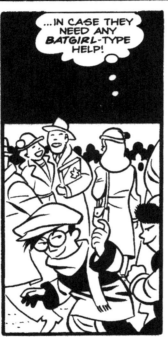

...IN CASE THEY NEED ANY *BATGIRL-TYPE* HELP!

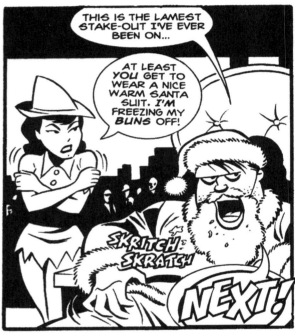

THIS IS THE LAMEST STAKE-OUT I'VE EVER BEEN ON...

AT LEAST *YOU* GET TO WEAR A NICE WARM SANTA SUIT. *I'M* FREEZING MY *BUNS* OFF!

SKRITCH SKRATCH

NEXT!

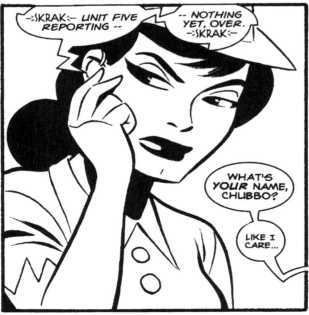

-SKRAK- *UNIT FIVE* REPORTING --

-- NOTHING YET, OVER. -SKRAK-

WHAT'S *YOUR* NAME, CHUBBO?

LIKE I CARE...

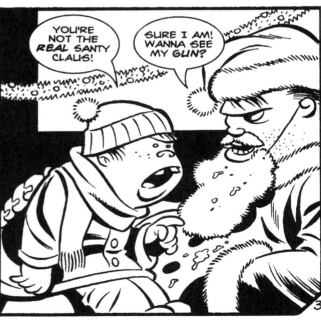

YOU'RE NOT THE *REAL* SANTY CLAUS!

SURE I AM! WANNA SEE MY GUN?

3

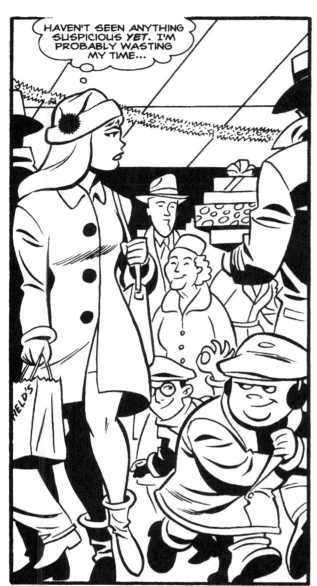

HAVEN'T SEEN ANYTHING *SUSPICIOUS* YET. I'M PROBABLY WASTING MY TIME...

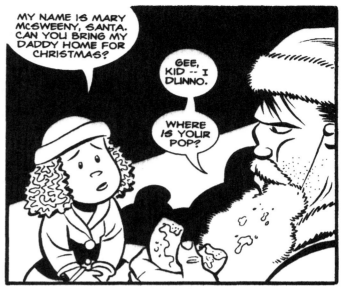

MY NAME IS MARY MCSWEENY, SANTA. CAN YOU BRING MY DADDY HOME FOR CHRISTMAS?

GEE, KID -- I DUNNO.

WHERE IS YOUR POP?

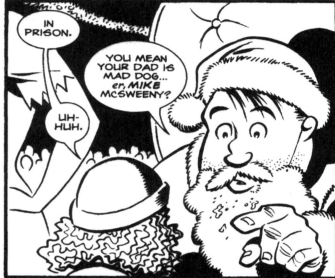

IN PRISON.

UH-HUH.

YOU MEAN YOUR DAD IS MAD DOG... er, MIKE MCSWEENY?

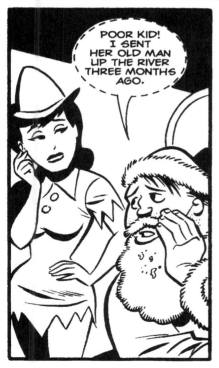

POOR KID! I SENT HER OLD MAN UP THE RIVER THREE MONTHS AGO.

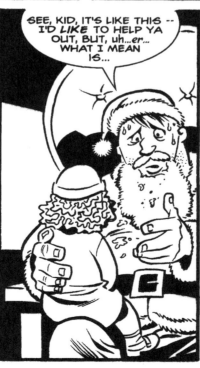

SEE, KID, IT'S LIKE THIS -- I'D *LIKE* TO HELP YA OUT, BUT, uh...er... WHAT I MEAN IS...

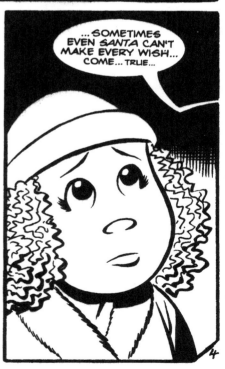

...SOMETIMES EVEN SANTA CAN'T MAKE EVERY WISH... COME... TRUE...

4

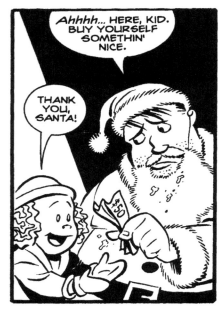

AHHHH... HERE, KID. BUY YOURSELF SOMETHIN' NICE.

THANK YOU, SANTA!

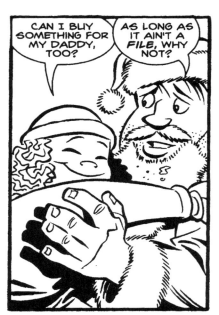

CAN I BUY SOMETHING FOR MY DADDY, TOO?

AS LONG AS IT AIN'T A *FILE*, WHY NOT?

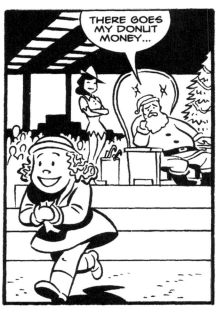

THERE GOES MY DONUT MONEY...

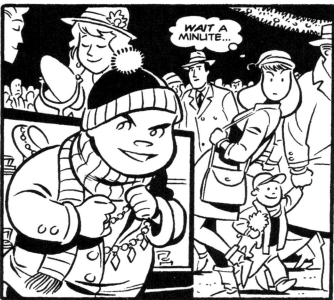

WAIT A MINUTE...

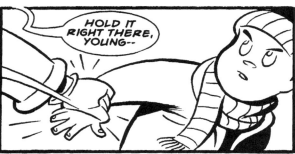

HOLD IT RIGHT THERE, YOUNG--

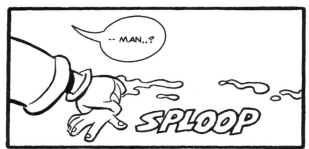

-- MAN..?

SPLOOP

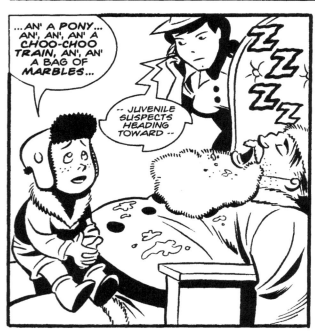

...AN' A PONY... AN', AN', AN' A CHOO-CHOO TRAIN, AN', AN' A BAG OF MARBLES...

-- JUVENILE SUSPECTS HEADING TOWARD --

ZZZ

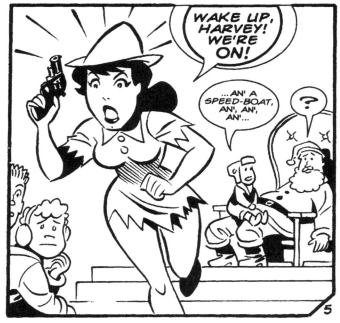

WAKE UP, HARVEY! WE'RE ON!

...AN' A SPEED-BOAT, AN', AN', AN'...

?

5

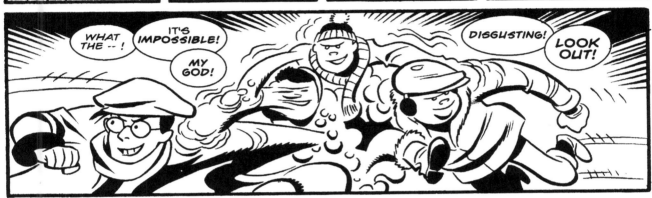

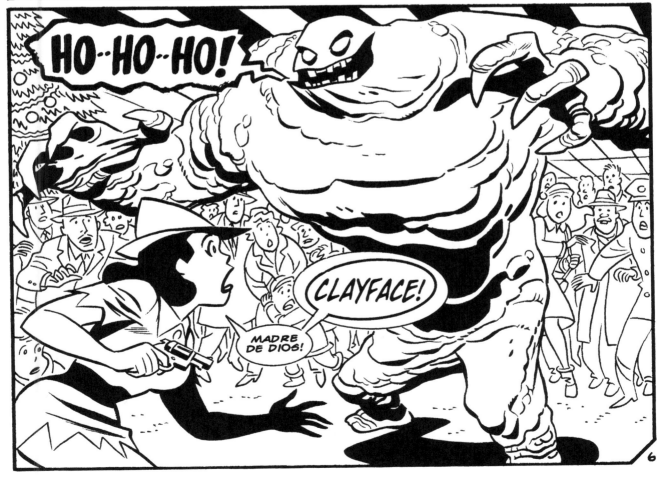

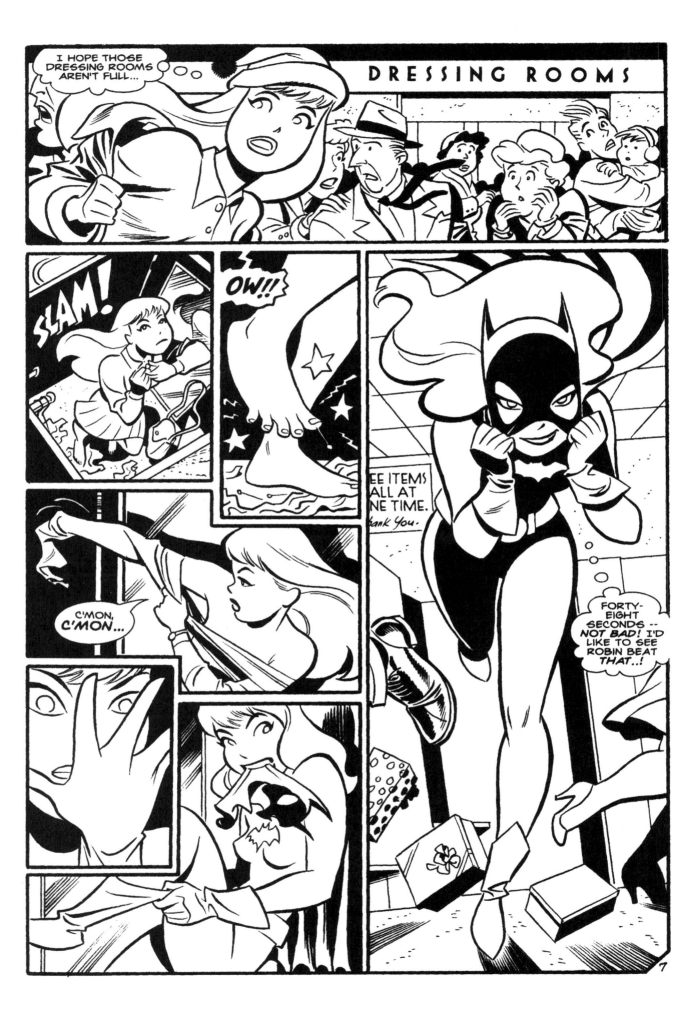

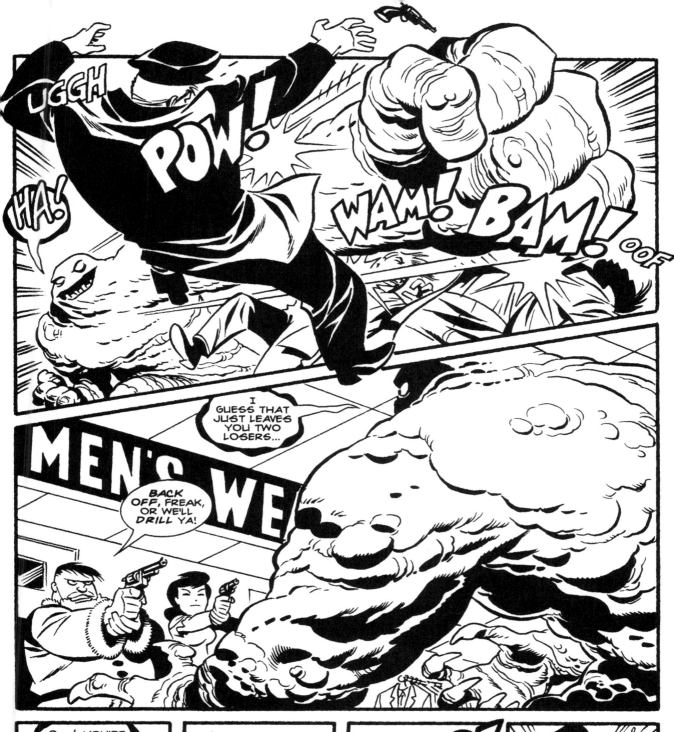

8

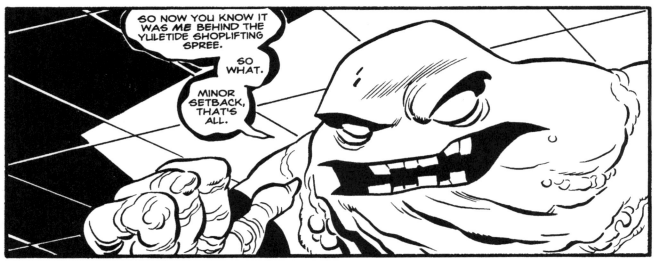

SO NOW YOU KNOW IT WAS *ME* BEHIND THE YULETIDE SHOPLIFTING SPREE.

SO WHAT.

MINOR SETBACK, THAT'S ALL.

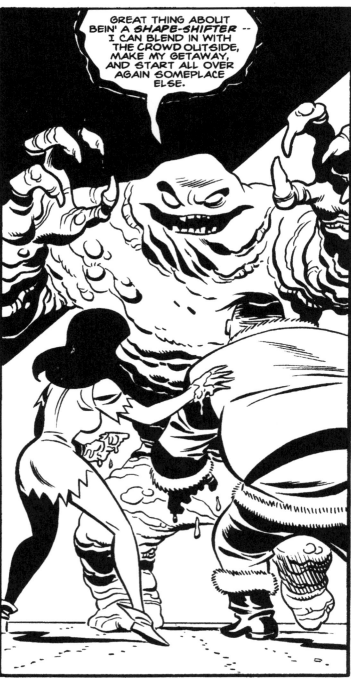

GREAT THING ABOUT BEIN' A *SHAPE-SHIFTER* -- I CAN BLEND IN WITH THE CROWD OUTSIDE, MAKE MY GETAWAY, AND START ALL OVER AGAIN SOMEPLACE ELSE.

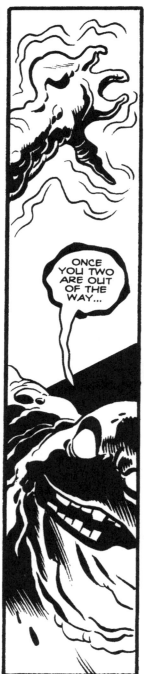

ONCE YOU TWO ARE OUT OF THE WAY...

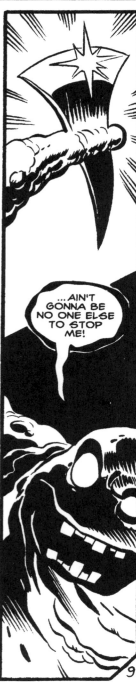

...AIN'T GONNA BE NO ONE ELSE TO STOP ME!

9

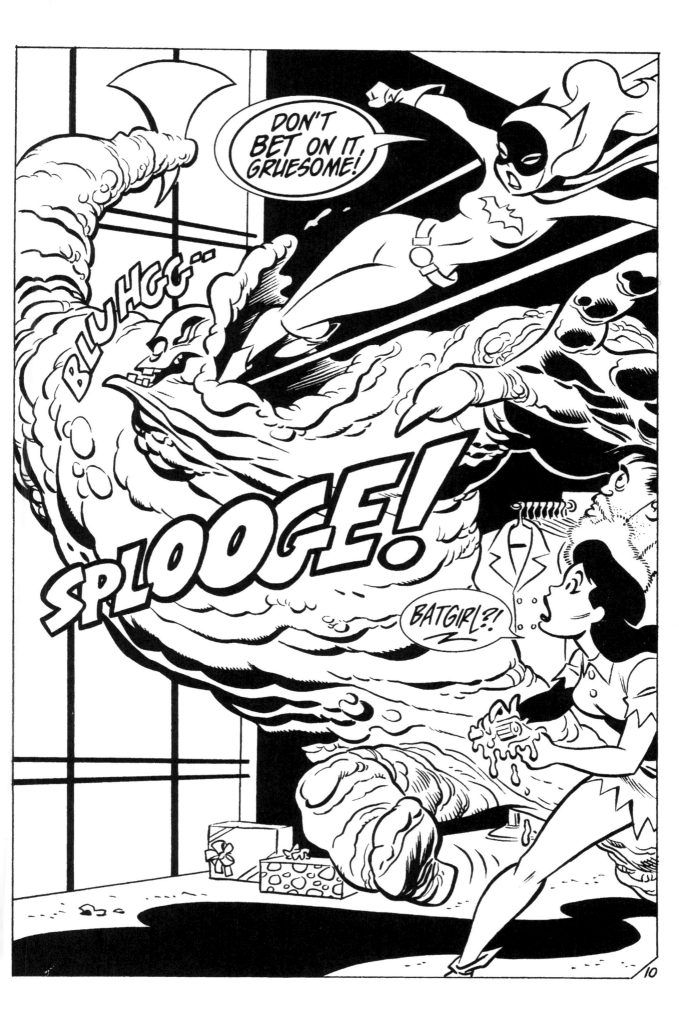

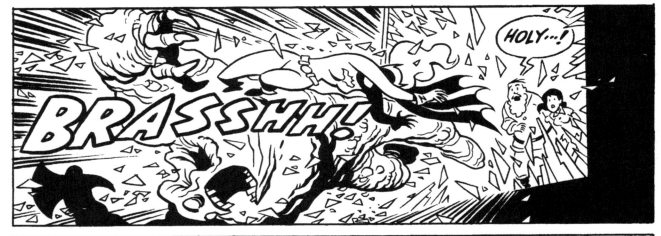

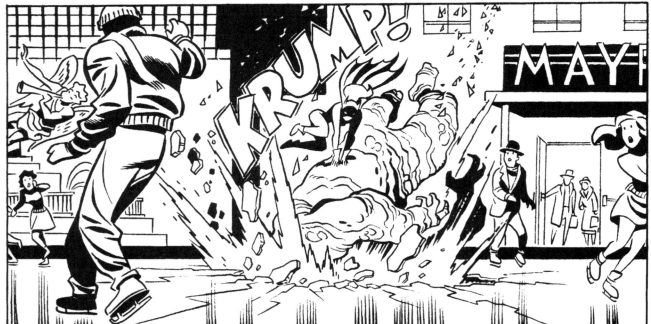

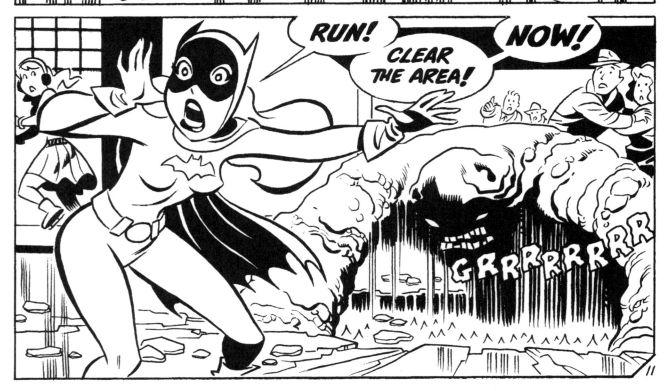

11

WHOA!

SHRIIPP!

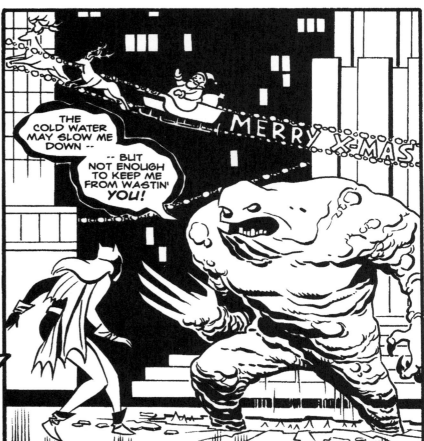

THE COLD WATER MAY SLOW ME DOWN --

-- BUT NOT ENOUGH TO KEEP ME FROM WASTIN' YOU!

MERRY X-MAS

THERE THEY ARE!

BDOOM BDOOM

AIM HIGH!

BAM

BAM

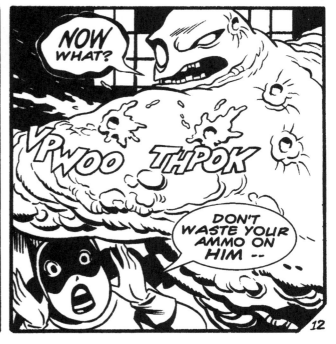

NOW WHAT?

VPWOO THPOK

DON'T WASTE YOUR AMMO ON HIM --

12

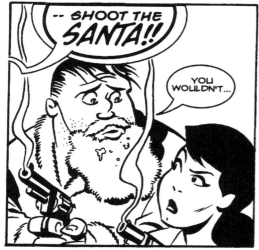

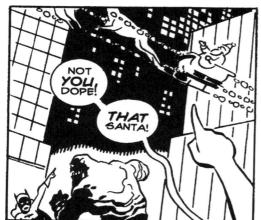

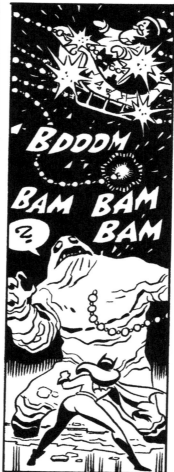

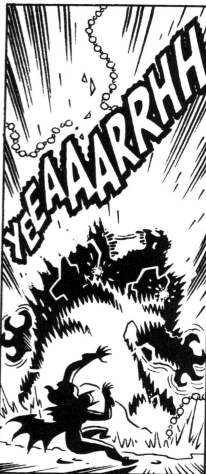

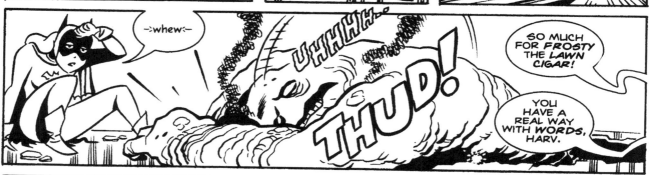

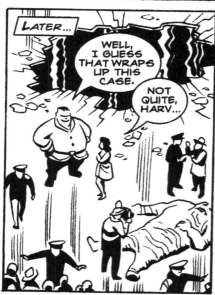

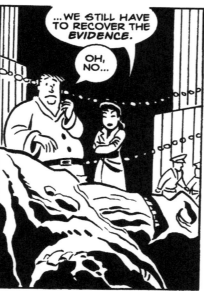

THE END